Art and Writing Throughout the Year

Merrill K. Watrous and Irisa Tekerian

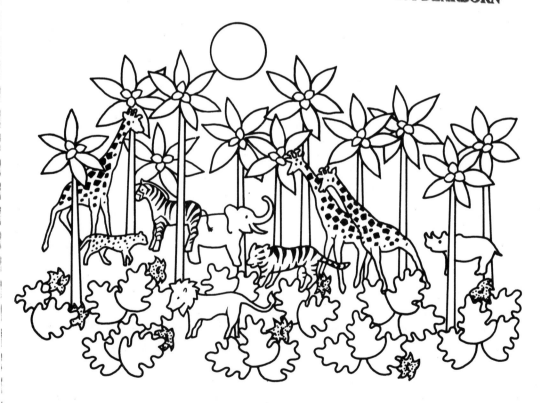

Fearon Teacher Aids

Carthage, Illinois

To our husbands and children: Willis and Yesso, Tatiana, Malena, and Alexandra
To our parents and parents-in-law: Mary Ann, George, Aina, Barbara, Willis, and Verjine

Their patience, love, and support helped us see this book through to its completion.

Entire contents copyright © 1989 by Fearon Teacher Aids, 1204 Buchanan Street, P.O. Box 280, Carthage, Illinois 62321. However, the individual purchaser may reproduce designated materials in this book for classroom and individual use, but the purchase of this book does not entitle reproduction of any part for an entire school, district. or system. Such use is strictly prohibited.

ISBN 0-8224-0499-0

Printed in the United States of America

1. 9 8 7 6

Contents

Introduction

Teaching art and writing together stimulates the imagination and nurtures children emotionally. Through their art and their writing, children can tell us a lot about themselves. Frequently, children who are the most articulate writers are less talented artistically, while those who are the most talented artists may be less able writers. When art and writing are taught as a single unit, the work of more children can be honored. The projects in this book are designed to help you do this.

A Few Words about Art

Many professors of art education emphasize the importance of the artistic process itself but pay little attention to its end product. They scorn the use of any kinds of models, recoiling in horror from the thought of twenty-five similar bunnies hopping across a second-grade bulletin board. Teachers are urged to encourage young children to experiment with various media—just set up baker's dough, paint, and printing centers and you're set in the early grades. As the children grow, formal instruction in the color wheel and the concepts of line, shape, pattern, and perspective is advised. For many teachers, this advice translates into a weekly art lecture of short duration followed by a simple drawing or coloring activity. Thus the children are kept busy while the teacher is able to retire from the fray to attend to necessary paperwork.

Conscientious teachers realize that this approach may be less than inspired, but they feel unprepared to follow any other course. If you wish to teach art well, it is not enough to teach the same basic concepts repetitively for many years or to simply provide materials in centers for students to use or abuse at will. Five-year-olds today enter kindergarten having spent one or more years in day care or preschool. They've already played at length with crayons, paint, and clay before they enter that first kindergarten classroom. Young children need more from us than materials; older children need more than the color wheel. To experience success in art is to create something that is aesthetically pleasing to both the artist and others.

Children cherish art, and as teachers, we cherish children. We must learn to value what they value. You may successfully teach art whether or not you see yourself as a talented artist. I remember hating art in school—it was a time of frustration for me. I tried to please the teacher but ended up spending hours on projects with which I had little hope of success. Like most of the class, I'd admire the work of the talented five percent, muck about with materials during the allotted time, and clean up enthusiastically. However, at home I spent many hours on crafts and projects with which I *was* successful: weaving, sewing, painting, and sculpting with edible clays. The child that I was possessed excellent fine-motor skills, a desire to create, and some modest ability. These were not nurtured in school. My real art training came many years after graduation from a friend and colleague, the coauthor of this book, Irisa Tekerian.

All of the art activities that she has put together for this book provide room for individual artistic expression. I hope that you and your students will be able to learn from them as I and my students have. When I used these projects in my classroom,

several children who rarely "succeeded" in art before became quite successful. A few years ago, a boy with learning problems who had tremendous difficulty just using scissors, said to me, "I like art the best of everything we did this year because I made neat things. You know what? I'm good at art now."

A Few Words about Writing

Writing should be a regular part of the daily routine in every elementary classroom, and students need to write across the curriculum. Many teachers fail to require this. Instead, they hand out fill-in-the-blank English workbooks. Children do need to learn to punctuate, spell, and write topic sentences. But if teachers only comment on the *mechanics* of a student's writing, they are not responding to the message behind the misspelled words or the badly organized sentences. On the other hand, when teachers go beyond the limiting workbooks, and write for and with their students, both the teachers and students grow together as writers and as friends. When you ask sincere questions about a student's topic—whether it is baseball or ballet—you will motivate the child to write in greater detail.

Writing is hard work. You must do it before you can teach it. I write at my desk every day while my students write at theirs. We've shared perceptions, experiences, and feelings through writing—both formally and informally. Every day I have my students write in hardback lined journals, and I respond to their work by writing in these same journals. The students have no agenda or syllabus; they are free to write about what is important to them. (I do have a Writing Box and topic list for blocked writers but few children depend on these.) They write about games won or lost, problems with friends, and worries about school or family life. They ask me questions in writing, and I answer these in writing and ask additional questions of my own. Each child keeps the journal and a reading book in his or her desk. When their seatwork is finished, the children are allowed to either read, write, or illustrate a journal entry.

I also teach a formal writing class every week of the academic year. I brainstorm topics with students in large groups, supervise them in writing-response groups, and meet with them for individual writing conferences. It is during the formal periods of instruction that I introduce my students to the mechanics of writing. I often use writing plans like the ones in this book to give some structure to the students' writing and to help them understand the importance of organization. I also make writing an integral part of my math, science, and social studies classes. For example, in math, children compose their own word problems.

When students write on a regular basis, the changes in the fluency, style, and structure of their writing from September to June are quite obvious. Children even come to enjoy the process. One of my fourth-graders once wrote, "It's fun to write the things that you can imagine. You can create with your mind." The year before, another fourth-grader concluded her year-end evaluation with these words, "I'm finishing my fourth-grade year and I learned a lot, especially to write with pizzazz." Teaching children to express themselves with pizzazz, in both writing and art, is what this book is all about.

Merrill Watrous

How to Use This Book

This book contains nineteen art and writing units. Each unit includes three sections: a teacher's guide, two writing plans (one for primary students and one for middle-grade students), and one or two art activities. These units are designed to showcase the daily work of the child and teacher in the classroom. While the projects are sometimes elaborate or time-consuming, they provide a great deal of satisfaction for everyone involved and can be displayed with pride throughout the year. Both the art and writing activities are meant to supplement the classroom routine and to motivate young children to write and create on their own. It is unlikely that you will be able to do all the units in a single year, so pick the ones that seem to fit the ability levels and interests of your students.

About Using the Units

The "Using the Unit" sections will provide you with basic guidelines for using the projects in your classroom. These guidelines tend to be more detailed for the units used at the beginning of the year, since children need more guidance at this time. The introduction to each unit will also give you suggestions for making the units the focal points of celebrations and social studies units.

About Writing Plans

The reproducible writing plans are meant to be used for organization and as a springboard for the actual writing. Some of the plans are more structured than others. For example, in some plans, sentences are started for the children and there are specific requests for details. In other plans, students are asked to research facts on a given subject and to integrate these facts with their own opinions into a full report. The writing plans may be duplicated as is or changed to meet the needs of individual students.

Going on a field trip, listening to a story, talking with a friend—all of these are PREWRITING experiences. PREWRITING is anything you choose to do before you begin to write which helps you to get started. The writing plans included in this book are only one kind of prewriting structure. Students need to be exposed to a variety of lesson formats. Students also need to choose their own topics regularly. When you do use these writing plans with middle grade students, remember that they are only *guides* to thinking and discussion. If used as a discussion guide, you might not choose to duplicate a writing plan at all, or you might only make copies for half the class and ask students to share. If you do make copies of the plans for your whole class, collect the writing plans from the students before the children actually begin to write their first drafts in class. *Do not allow students to simply string together answers to questions from a writing plan or you will never be able to hear your children's own voices in their writing.*

I also ask my students to work in pencil—this makes it easier for them to change details as they go along and to correct errors when they revise. You should point out that revision and proofreading are an important part of the writing process. You might want to make an "editor's checklist" for the children to use as they write. Older children should each have a lexicon (see Appendix A, page 174). Without a lexicon, some students will limit their written vocabulary to easily spelled words. For example, the child who wants to write "ecstatic" may spell it h-a-p-p-y. Do not spell for students while they are composing. Use the lexicons only to help students revise final drafts.

About Art Activities

The art projects in this book are designed to provide artistic success for all children. For this reason, most of the art projects are highly structured. Each activity contains a complete materials list, detailed directions, and, if applicable, reproducible patterns. Lead the students through the student directions. (These pages are not meant for reproduction.) Try to adhere precisely to the directions the first time around, before attempting to modify them. The particular materials, patterns, and color schemes for each project are the result of numerous preliminary designs and extensive experience with children. Modification might result in a far less aesthetic project than intended.

If possible, you should always make your own models before introducing a project in class. This will allow you to understand the steps involved and to anticipate the areas where your students may need assistance. You will also be able to appreciate the artistic principles involved and to introduce these principles more easily to your class.

Stress care and craftsmanship in your classroom. Thinking, planning, writing, correcting, and careful revision are the prerequisites of an excellent written composition. Thinking, sketching, evaluating, and careful final drawing or painting are the prerequisites of an excellent piece of art. Although preliminary design work cannot always be expected of very young children, older children are quite capable of this type of planning. Whenever possible, ask these children to do practice designs before they draw or paint the final designs. Also, good tools are essential. A small, shared supply of sharp quality scissors is preferable to a classful of cheap dull ones, fine-tipped markers and paintbrushes give superior results, and quality drawing paper is more pleasing than newsprint.

The King or Queen of the Beasts

Every September, in many elementary classrooms across the nation, class officers are elected. This unit will encourage children to start thinking about what qualities are important in a leader and will allow them to campaign and vote intelligently. The children should complete all parts of the writing and art projects before the fall elections are held. (An added bonus of doing this unit early in the school year—the stories and jungle scene make a colorful display for Back-to-School night.)

Using the Unit

Because it is the beginning of the school year, I take a week to do the projects. The lesson plan I use looks something like this:

Monday: Explain to the children that they will be learning about African animals. Ask them to name all the African animals they can think of. Write the names on the chalkboard, and next to each name try to write a descriptive word or phrase.

Tuesday: Take the class to the library and have them look through books about African animals. Ask the children to simply read the books for information and pleasure. Do not stop any child from taking notes, but do not encourage them to do so. When you return to the classroom, read the King of the Beasts story (page 6). Discuss leadership qualities with the class.

Wednesday: Duplicate and pass out the primary or middle-grade writing plans (pages 7 or 8–9). Ask each child to choose one animal to write about. Also have the children name their animals. Explain the concept of alliteration and ask the class to pick names that begin with the same letter or sound as the name of the animal they are writing about. For example, they might choose Leo the Lion, Charlene the Cheetah, or Gerry the Giraffe.

Thursday: Start making the Cooperative Jungle Scene (page 10.) Allow the children to make any African animal—they do not have to make the same animals that they wrote about. The details, such as stripes or spots on the animals, should be done on Friday. Also have children make the jungle foliage at this time.

Friday: Have the children finish the details of the jungle scene. Once they finish, hand back the writing plans with comments. The children can then refine and revise their letters or paragraphs. When you are satisfied with the final revisions, have the children neatly copy the letters or paragraphs. Mount the finished papers on construction paper. After school, assemble the jungle scene on a wall. (You may want to get the help of student or parent volunteers.)

Monday: Before class, read through the papers and choose eight finalists as possible candidates to take Leo's place. Once class starts, explain to the children that you are going to read eight papers aloud. The children will have to vote and decide which of the eight animals will be the new king or queen of the jungle. Ask the children to take notes as you read. Point out that they will not be able to write every word that you say. Explain that they should choose *key* words that will help them remember what you have said about each animal.

Give the class time to number from one to eight on their papers, and then slowly read out loud and spell the names of the eight animals. Remind the children to leave several lines of space between each name. Then read the letters or paragraphs aloud. Do *not* give the names of the authors. After reading the papers, ask the children to vote for a new king or queen of the jungle. (You may want to choose two co-leaders if the election is a close one.) Place a small paper crown on the winner's animal in the jungle itself.

The King of the Beasts (A Jungle Story)

Once upon a time there was a tiny jungle kingdom, far from here in the middle of Africa. This jungle had the most magnificent trees of any jungle in Africa. The bright green leaves were as large as baby elephants' ears and were so shiny that young monkeys liked to use them as mirrors. The trees grew so close together that many animals rarely saw the sun, though they could feel its warmth.

Warm and wet, this jungle was a comfortable home for its animal inhabitants. Drops of dew would linger on the leaves of brightly colored flowers until a young hyena or leopard licked them dry. Coconuts full of meat and milk dropped from the trees without much coaxing, and breadfruit trees were plentiful. Life in this jungle was easy—food and drink were everywhere and man did not threaten its peace.

Occasionally, however, the animals would quarrel among themselves. When this happened, the animals would go deep into the darkest part of the jungle, to consult with Leo the Lion.

Leo was the King of the Beasts, and he ruled from an enormous throne. It had been built out of palm fronds and coconut husks by the gorillas and the gnus. Leo always listened carefully to both sides of any story and his decisions were fair. The rest of the animals obeyed his judgments without question, and the wisdom of his solutions was never doubted.

Leo had ruled over the animals for a long time. He knew that when he died there would be no one to take his place, for he had never mated and was the youngest of a small pride of lions. This knowledge lay heavy in his heart and he spent restless nights wondering what to do.

Finally he decided to call a meeting. He sent a honey guide to tell each animal community to send one representative to the throne room—safe passage was guaranteed to all animals. The animals knew the honey guide's raucous call, for it often led them to batches of hidden honey. (After the larger animals did the painful work of getting the honeycombs, the honey guide feasted on the leftovers.)

As the honey guide flew across the jungle, the leader of each animal family made his or her way to Leo's throne. The monkey skipped without fear next to a cheetah. A bush baby rode on the back of a wart hog. An elephant lumbered slowly through the trees, taking care not to step on any small creatures by mistake. Finally, after one sunrise and one sunset, the leaders of each animal family found themselves huddled near Leo's throne, anxious to hear his news.

Leo appeared and moved slowly toward his throne. "Welcome, my friends," he greeted them softly. "I have called you here to tell you that I am going to retire."

"Eeeeeeek!" "Arrrrgh!" "Sssssss!" "Chirrrup!" "Harrrrrumph!" The jungle was filled with the cries of agitated animals. Their noise rustled the leaves of the trees above them; the stomping of their feet shook the ground.

"Silence!" roared Leo. "Hold still and listen. I have made my decision and it's quite final. I am very tired and I am going to step down. One of you must take my place. Go home and talk to your families and friends. Think about which one of you is most fit to be the new King or Queen of the Beasts. Come back when the moon is full, and tell me why you think you should take my place. I will listen to any of you who wish to speak. Then I will decide."

Leo jumped off the throne and disappeared into the jungle. The other animals left in silence. Some rushed eagerly home with the news, others moved more slowly. All the beasts knew that a new leader would be chosen in one month's time, and they had a great deal of thinking, discussing, and planning to do before that day. So do we.

A Letter to Leo

Leo the Lion is going to retire—he is no longer going to be the King of the Beasts. Write a letter to Leo that explains why you think you should take his place.

Dear Leo,

Don't worry, you can retire in peace from your job. I can help you. I can take your place!

I am good at _____

I know how to _____

The other animals all say I _____

Please choose me to take your place. I promise to be a responsible leader.

Love,

(Your animal name)

May the Best Animal Rule!

Leo the Lion is going to retire—he is no longer going to be the King of the Beasts. You are an African animal who wants to take his place. You need to convince the other animals that you should be their leader.

Which African animal are you? _____

What is your name? _____

Make a list of words that describe what you are like.

_____ _____

_____ _____

_____ _____

_____ _____

List the qualities you think a good leader should have and why you think these qualities are important.

Qualities	Reasons
_____	_____
_____	_____
_____	_____

How would you help the other animals if you were the King or Queen of the Beasts?

Art and Writing Throughout the Year © 1989

May the Best Animal Rule! *(continued)*

Read through your ideas. Use the information to help you write three short paragraphs that explain why you should be elected as the new King or Queen of the Beasts. For each paragraph, explain in detail one reason why you should be chosen. Write the paragraphs on the lines below.

1. _____

2. _____

3. _____

Cooperative Jungle Scene

Materials for Animals

- Animal patterns (pages 12–16) or drawing paper for students to make their own patterns
- Tagboard
- Paints: yellow, white, brown, gray, orange, and black
- Scissors, tape, paintbrushes, and pencils

Teacher Preparation for Animals

1. Duplicate the animal patterns for students to use as templates.
2. Mix and set out the base colors for the animals. I use tawny yellow for the lions, tigers, and leopards; creamy yellow for the giraffes and cheetahs; gray for the elephants and rhinoceroses; white for the zebras and ostriches.

Student Directions for Animals

1. Choose an animal pattern or draw your own. (Note to teachers: If students draw their own patterns, make sure they are careful with small parts, which they will then have to cut out.)
2. Either cut out the pattern and trace around it on a piece of tagboard, or tape the pattern onto the tagboard and cut out both together.
3. Paint the animal the appropriate base color and let it dry.
4. Use a reference book to find out the pattern on your animal's coat. Lightly pencil in stripes or dots if your animal has them. Then paint over the pencil lines with the appropriate colors.

Materials for Foliage

- Foliage patterns (pages 17–18)
- Construction paper: brown, dark green, orange, magenta, and purple
- Brown markers (for palm trees)
- Yellow pipe cleaners (for flowers)
- Orange and yellow paint (for flowers)
- Paintbrushes, scissors, tape, glue, and pencils

Teacher Preparation for Foliage

1. Duplicate the patterns for children to use as templates.

Student Directions for Foliage

For palm tree:

1. Cut out the trunk pattern and tape it together on the dotted lines. Trace around the pattern on a large piece of brown construction paper. Cut out the trunk.
2. Use a brown marker to draw horizontal lines across the trunk.
3. Cut out the palm leaf pattern. Trace around the pattern six times on dark green construction paper. Cut out the leaves and cut slashes in each leaf where indicated. Glue the leaf ends to the top of the trunk.
4. Cut out the coconut pattern. Trace around the pattern on brown construction paper and cut out. Glue to the center of the palm leaves.

For jungle flower:

1. Cut out and trace the flower pattern onto orange, magenta, or purple construction paper.

2. Use orange or white paint to cover the flower with tiny dots. Let the paint dry.

3. Cut out the flower. Curl the flower into a cone, with the overlap flap on the inside of the cone. Tape the ends in place. Curl each triangular petal around a pencil away from the inside of the cone.

4. For the stamen, pinch one end of the pipe cleaner into a ball. Insert the straight end into the flower, and pull through for the stem.

For bush:

1. Cut out the bush leaf pattern. Trace around the pattern three times on dark green construction paper.

2. Cut out the leaves. Glue them together at the bottom to form a fanlike bush.

Materials for Display

- Large pieces of dark blue construction paper or fadeless art paper
- Tape or stapler
- Gold paper or marker (for sun)

Teacher Directions for Display

1. Put up the dark blue paper for a background.

2. Put up the palm trees. Start by putting up five or six, spaced fairly evenly across the background. Then put up the rest of the trees, starting in the middle area. Place them in a random arrangement among the first row of trees.

3. Tape one flower to the back of each bush. Put up the bushes below the palms.

4. Put up the animals, scattering them among the palm trees.

5. Add a sun, using a circle of gold paper or a gold marker.

(Note: When you want to take the display down, help each child mount his or her animal and plant on a large piece of blue paper. Let the children add a sun, using gold paper or a gold marker if they wish.)

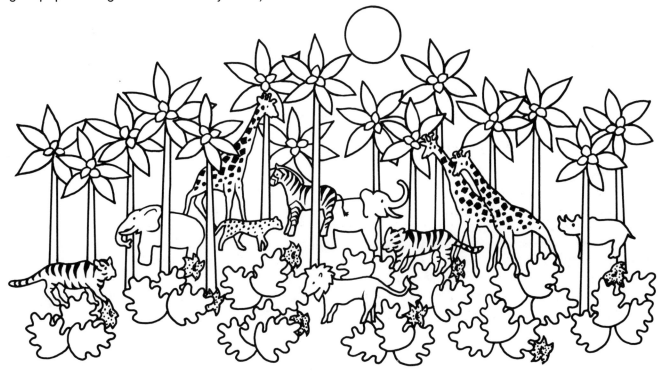

Cooperative Jungle Animal Patterns

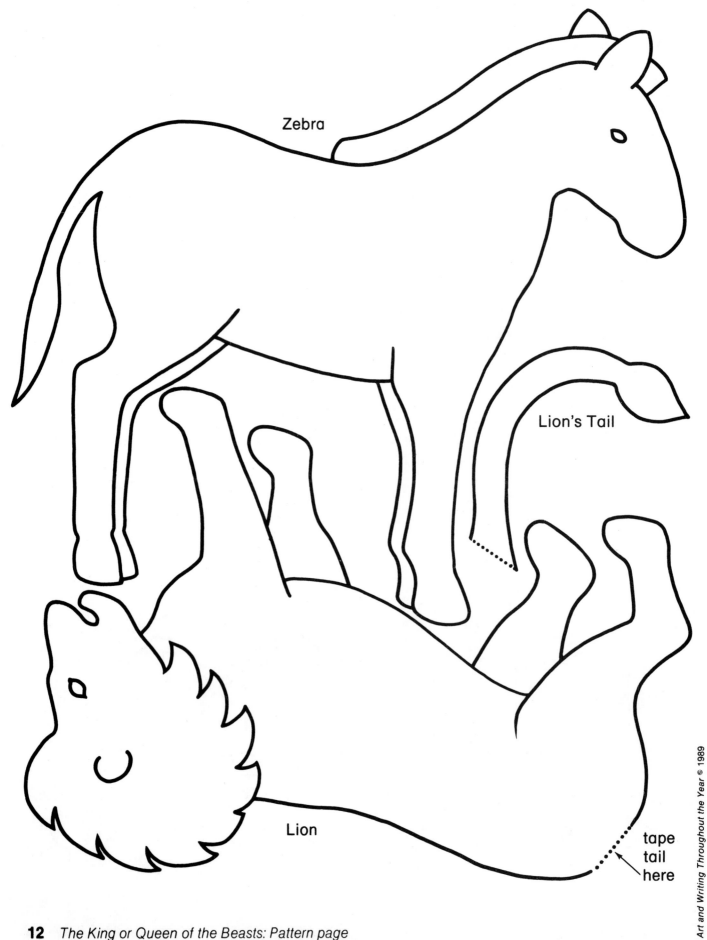

Zebra

Lion's Tail

Lion

tape
tail
here

Cooperative Jungle Animal Patterns

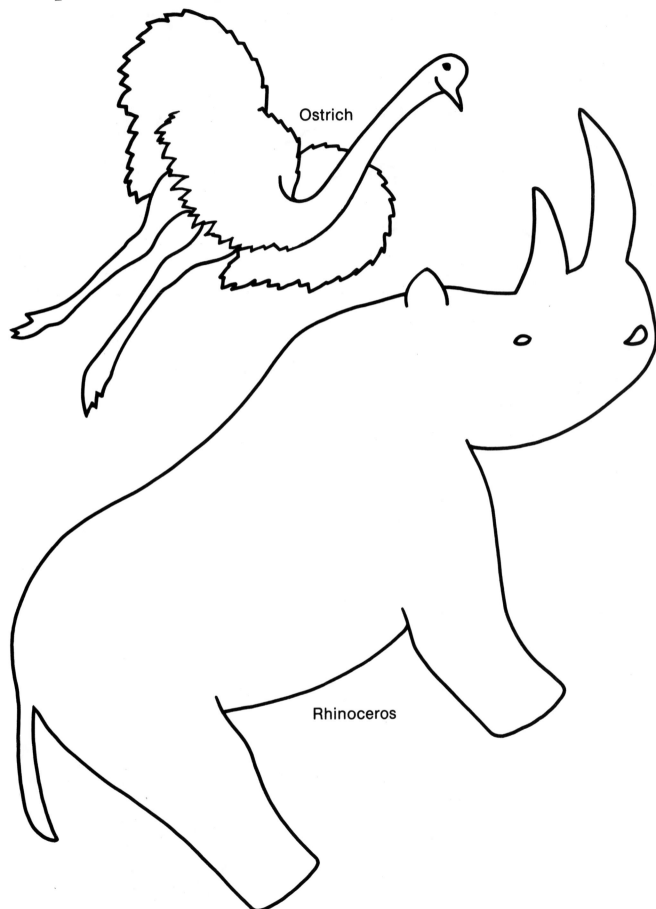

Ostrich

Rhinoceros

Cooperative Jungle Animal Patterns

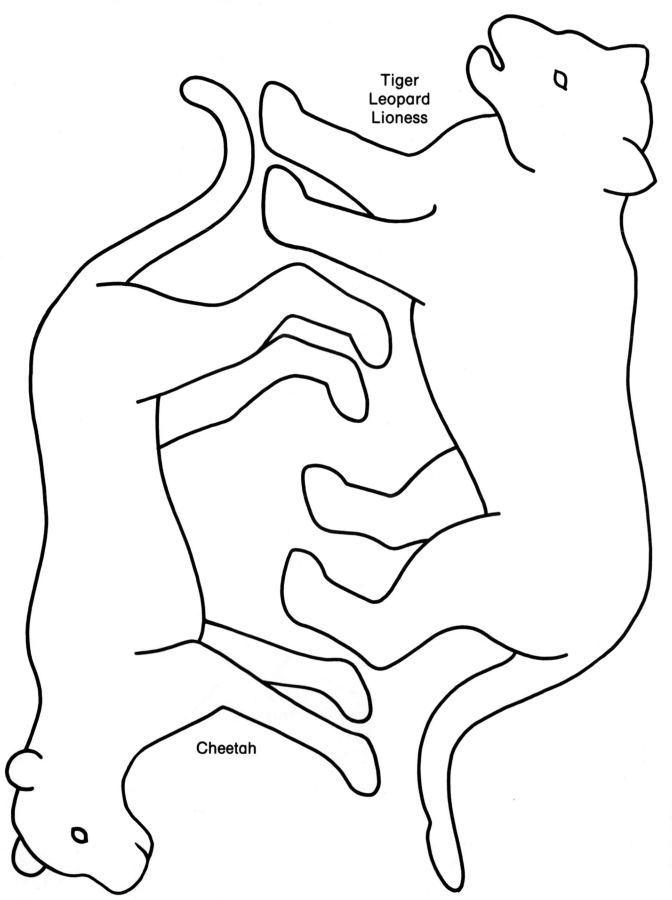

Tiger
Leopard
Lioness

Cheetah

Art and Writing Throughout the Year © 1989

Cooperative Jungle Animal Patterns

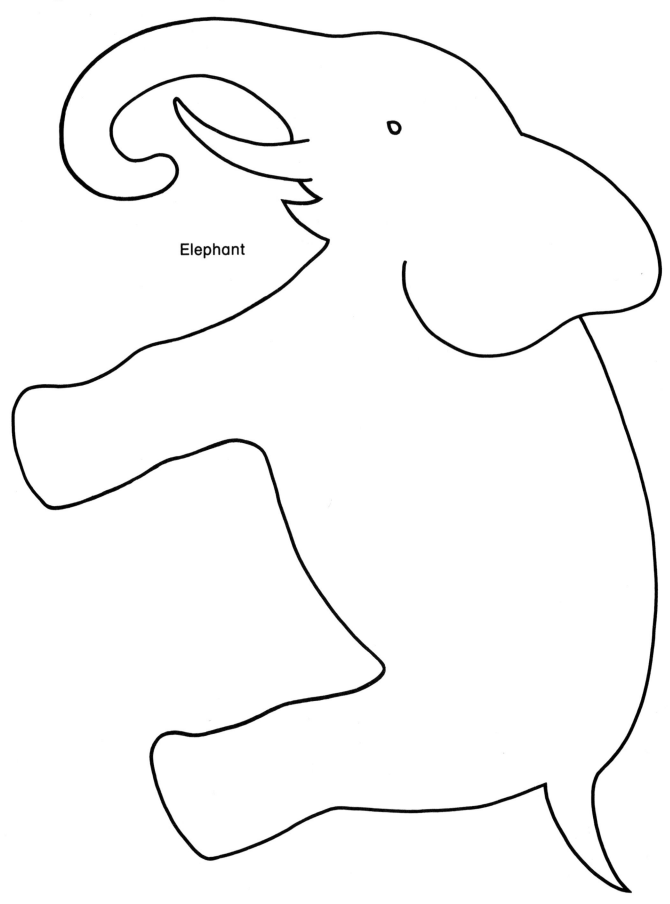

Elephant

Cooperative Jungle Animal Patterns

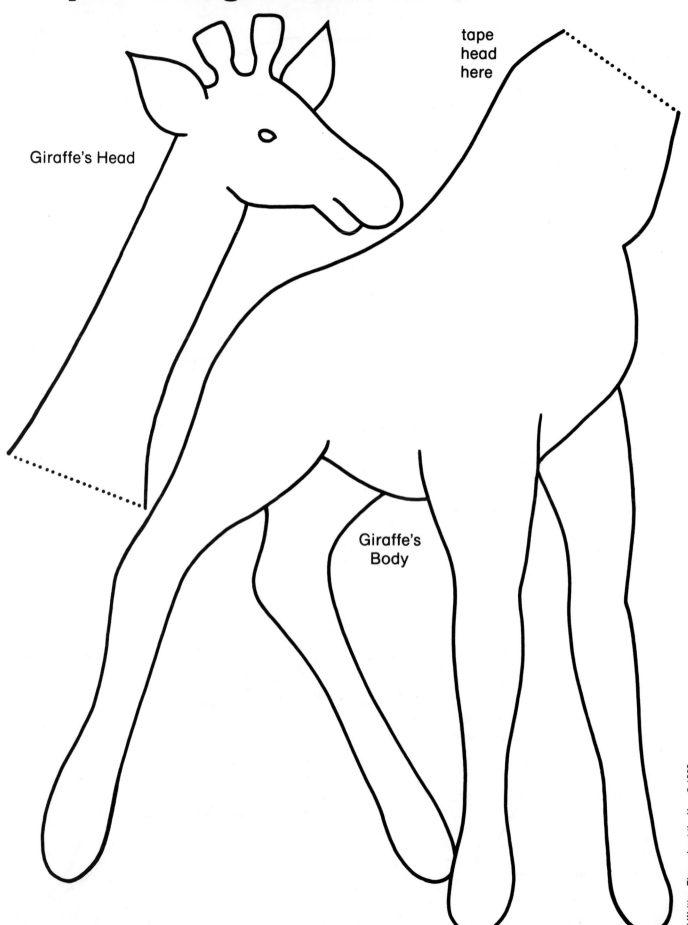

tape
head
here

Giraffe's Head

Giraffe's
Body

Cooperative Jungle Foliage Patterns

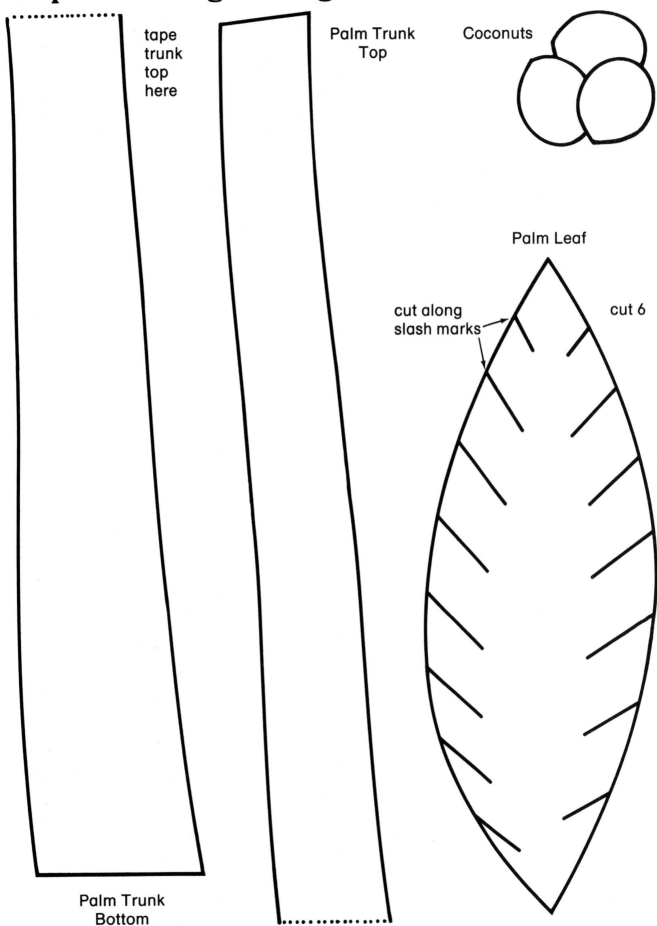

tape
trunk
top
here

Palm Trunk
Top

Coconuts

Palm Leaf

cut along
slash marks

cut 6

Palm Trunk
Bottom

Cooperative Jungle Foliage Patterns

Jungle Flower

overlap →

Bush

cut 3

Art and Writing Throughout the Year © 1989

Apples

Apples are very popular with younger children. If you are using the Seasonal Reading Tree (Appendix B, page 176), you could use a basic apple pattern for reading records. Apples in September are particularly appropriate since they can be tied into a lesson on John Chapman (Johnny Appleseed), who was born in September. You might want to try some of the following ideas, along with the writing and art projects, to enhance the apple theme.

- Have students make applesauce in a Crockpot, using apples, water, brown sugar, and cinnamon. If you can, try to find an old-fashioned apple peeler-and-corer. Children are fascinated by this tool. Preparing apples with it allows small children to break the apples into small pieces.
- Have the children read about John Chapman's life in an encyclopedia. Then encourage the class to write haiku poems about apples, Johnny Appleseed, or fall. Remind them to use the 5–7–5 syllable pattern.
- Turn common expressions into rebus puzzles. For example, you might start by drawing the following expression on the blackboard:

Then have children think of ways that other common sayings can be written with rebus pictures.

Using the Unit

For younger children, duplicate and hand out the Annie the Apple writing plan (page 20). Have them fill in the blanks with one of the words listed below each blank. When the children have finished writing, ask them to copy their story carefully on a clean sheet of paper, adding the last sentence that they wrote themselves. Then have the children draw and color an apple to illustrate their stories.

For older children, duplicate and hand out the Three-Step Apple Drawing instructions (page 24). Also give each child an apple. Read through the directions with the class, then have the children complete the project.

When the class has finished their drawings, read the story of *The Giving Tree,* by Shel Silverstein. Ask the children to think about their apples as you read. Remind them that the apples gave their all to be models and snacks. When you have finished reading, ask the class to imagine that their apples had feelings, like Silverstein's tree. Have the children close their eyes and sit quietly for a few minutes, daydreaming about their apples.

Duplicate and hand out the Adam the Apple writing plans (pages 21–23). Have the students work in pencil, so they can change details as they go along and correct errors easily. Point out that the writing plan will help them organize their stories—they can add more information if they wish. The final stories should be about two pages long.

Annie the Apple

Annie the Apple lived in a tree. She had a very peaceful life. Then one day something happened to Annie.

Help Annie tell her story. Complete the story by picking one of the words below each blank. Write the word in the blank.

Annie the Apple's Story

I was sitting on my branch in the _____ apple tree.
 large/small

A little _____ walked by. "My, what a lovely
 boy/girl

_____ apple," the little _____ said.
 red/green boy/girl

_____ climbed up the tree and _____
 He/She picked/pulled

me off my branch!

Farmer _____ saw the little _____
 Joe/Bill boy/girl

take me. He was very _____ . The little
 angry/pleased

_____ _____ out of the orchard and
 boy/girl ran/skipped

took me to _____ _____ .
 his/her school/house

Write a sentence that tells what happened next.

Art and Writing Throughout the Year © 1989

Adam the Apple

This is the story of Adam the Apple. It tells about the day when Adam was picked off his branch and taken from his home. It was Adam's dying wish that his story be told, and he asked you to tell it.

(story title)

Describe the place where Adam grew. On what type of tree did he grow? Where was the tree located? Were there a lot of other apples on the tree or just a few?

Describe what Adam looked like. If there were other apples on the tree, how was Adam different from the rest?

Explain how Adam felt about his tree.

What was the weather like the day Adam was picked?

Art and Writing Throughout the Year © 1989

Adam the Apple *(continued)*

Describe the person who picked Adam. What was this person's name? What was he or she wearing? Where was he or she from?

List three things that happened to Adam just after he was picked.

1. _____

2. _____

3. _____

Explain what happened after Adam was taken into the house.

Describe the kitchen in the house.

Explain what happened in the kitchen when the dog was let in.

Art and Writing Throughout the Year © 1989

Adam the Apple (continued)

List four things the cook did to Adam.

1. _____

2. _____

3. _____

4. _____

Describe what happened to Adam's seeds.

When you have finished, reread what you have written. Add details where you think they are missing. Cross out ideas that you don't think will work. Hand in your writing plan and begin your story.

A Three-Step Apple Drawing

Read the instructions carefully before you start to draw. Then do each drawing. Use a separate piece of drawing paper.

1. Examine your apple. Is it perfectly round? Is it free of blemishes? Look at it from all angles, then set it down on your desk and draw exactly what you see. Keep your eyes on the apple as much as possible, and not on your hand. When you have finished, label this drawing *#1*.

2. Take three large bites out of your apple. Chew them slowly and savor the juice. Put your apple back down on your desk. Draw what you see now. Label this drawing *#2*.

3. Finish eating your apple, leaving only the core and enough of the bottom so the apple will stand on your desk. Draw only what you see. Label this drawing *#3*.

Art and Writing Throughout the Year © 1989

October Witches

Children of all ages are fascinated by witches, and October is the perfect time to introduce these intriguing creatures. Though you may want to postpone the Egg-Carton Witches and the witch or wizard stories until the end of the month, don't! Use this unit early in the month so the children can take home their projects to hang as door decorations on Halloween night.

Using the Unit

Have the children make the Egg-Carton Witches (page 30) before they begin to write. (I use the completed art projects to help motivate the children when they write their stories. One of my students was so inspired by his witch that he wrote a prize-winning Halloween story in a writing contest.)

Once the art projects are finished, stimulate your students' imaginations by reading witch stories aloud. I like to read one of the *Dorrie* books by Patricia Coombs to younger students and Roald Dahl's *Witches* to older students. Then I do the following prewriting activity with the whole class.

First, write the names of each of the five senses across the top of a chalkboard. Then have the children call out words and phrases that they would use when describing witches or wizards. Write each word in the appropriate column. Take time to discuss or define the words for each category, particularly in a class with mixed English fluency. If possible, try to draw rebus picture clues next to difficult words, and underline irregular spelling patterns. Stress the importance of using active verbs that are specific and descriptive. For example, "The witch cackled" is a better choice than "The witch said." Your board might look something like this:

Sight	Sound	Taste	Touch	Smell
ugly	cackle	poison brew	grasping	enticing
crooked	scream	eel's broth	gooey	like cinnamon
black	loud	bitter	skinny	garlicky
wrinkled	cry	watery	bony	foul
gnarled	whisper	sour	sharp	unclean
unkempt	mumble		slimy	pizza-scented

It is a good idea to erase the board before the children actually begin to write. Explain that these ideas are merely to get the class started. Each child should use his or her *own* ideas when writing the story.

If you are working with older children, try reading the first chapter of *A Wrinkle in Time*, by Madeleine L'Engle, before the children write their stories. Like the writing plan, this book starts with the line "It was a dark and stormy night." It's a line that children love to use, and it's a good way to introduce the concept of a narrative hook.

Duplicate and hand out the primary or middle-grade writing plans (pages 26 or 27–29). Remind the class that although the writing plans will help them organize their thoughts, they should not rely on the plans too much. (You should have children turn in their plans before they write.) Make sure you allow the children time to revise their work.

Display the Egg-Carton Witches and the final stories in the classroom or the hallway area. Try mounting the stories on black or orange construction paper and adding a harvest moon and a bat or cauldron to complete the display.

The October Witch

You are going to write a story about a witch. From the story parts below, choose a beginning and a middle. Write them on the lines. Then make up an ending for your story. Write the ending on the lines.

beginnings

Once upon a time, there was a very old witch who lived in a forest.

A witch moved into the run-down house next door!

The witch stood over the huge, black pot.

middles

She had long stringy hair, yellow teeth, and an evil laugh.

One day, a little girl decided to visit her.

There were only three days left until Halloween.

(story title)

Art and Writing Throughout the Year © 1989

A Scary Story

It was a dark and stormy night. High up on a hill, eerie lights flickered in the windows of an old, run-down house. Inside the house, a witch stood over a huge black cauldron. She was stirring the brew with a long wooden stick. Suddenly she realized she was missing a key ingredient.

Write a story that tells about the witch's hunt for the missing ingredient.

(story title)

Describe the witch. Was she a good witch or a bad witch? What did she look like? What was she wearing? What was her name?

List several words or short phrases that describe the house.

_____ _____

_____ _____

_____ _____

What was the witch making? What was the missing ingredient?

Art and Writing Throughout the Year © 1989

A Scary Story (continued)

List three things the witch had to do before she could look for the missing ingredient.

1. _____

2. _____

3. _____

Explain what happened to the witch when she left the house.

Describe characters that the witch met on her journey. What were their names? How did they help the witch?

Where did the witch finally find her ingredient? Describe the place.

Describe how the witch felt when she found her ingredient.

A Scary Story (continued)

What things happened to the witch on her way home?

Explain what happened when the witch added the missing
ingredient to the cauldron.

When you are finished, reread what you have written. Add
details where you think they are missing. Cross out ideas that
you don't think will work. Hand in your writing plan and begin
your story.

Egg-Carton Witches

Materials for Witches

- Witch patterns (pages 32–35)
- Dull or shiny black tagboard (available in art supply stores)
- Crepe paper in several colors
- Cardboard egg cartons (one for every two students)
- Pastel construction paper
- Glitter: red, purple, green, or violet
- Markers, scissors, glue, and tape

Teacher Preparation for Witches

1. Duplicate one copy of the body patterns to use as a template. Cut out the patterns and join them together as indicated on the patterns. Place the pattern on the fold of a large piece of folded construction paper. Trace around the pattern, cut out and unfold.

2. Trace around the completed body pattern on the back side (white side) of the tagboard. Make one body for each student. (You might want to have student volunteers help you with this.) Trace around the hat pattern on the back sides of the tagboard. Make one hat for each student.

3. Duplicate the hand, mouth, and leg patterns on pastel-colored construction paper.

4. Cut crepe paper into ½″ × 16″ strips for hair. (To do this quickly, fold up several 16″ lengths of crepe paper. Then slice together into ½″ pieces on a paper cutter.)

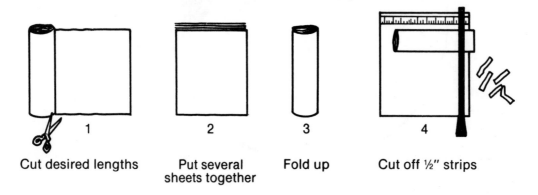

1	2	3	4
Cut desired lengths	Put several sheets together	Fold up	Cut off ½″ strips

5. Cut the bottoms of the egg cartons as shown.

6. Set up a table as a paint and glitter area.

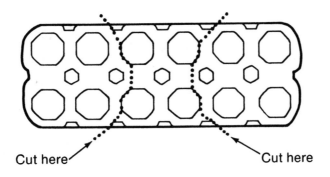

Cut here Cut here

Student Directions for Witches

1. Cut out the witch's body, hat, hands, mouth, and legs.

2. Use markers to make the eyes on the face of the witch. (Black eyes with glitter pupils are very effective.) Color and glue on the witch's mouth.

3. Tape or glue six or seven strands of crepe-paper hair to each side of the witch's head.

4. Make a design on the witch's hat with glitter. Let dry.

5. Glue the hat to the face. Put a book under the hat to prop it up while the glue dries.

6. Paint or draw designs on the witch's legs.

7. Glue the legs and the hands to the body. Let dry.

8. Glue the face to the body.

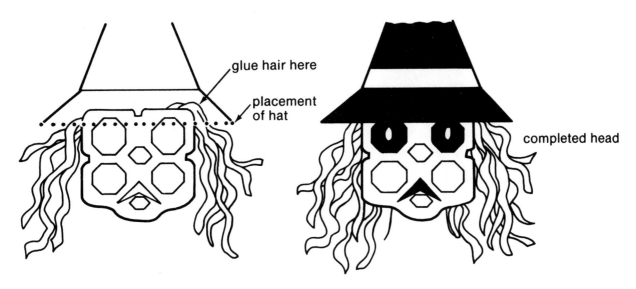

glue hair here

placement of hat

completed head

Witch Body Pattern

glue head here

Body Part A

place on fold line

join here to Part C

join here to Part B

Witch Body Patterns

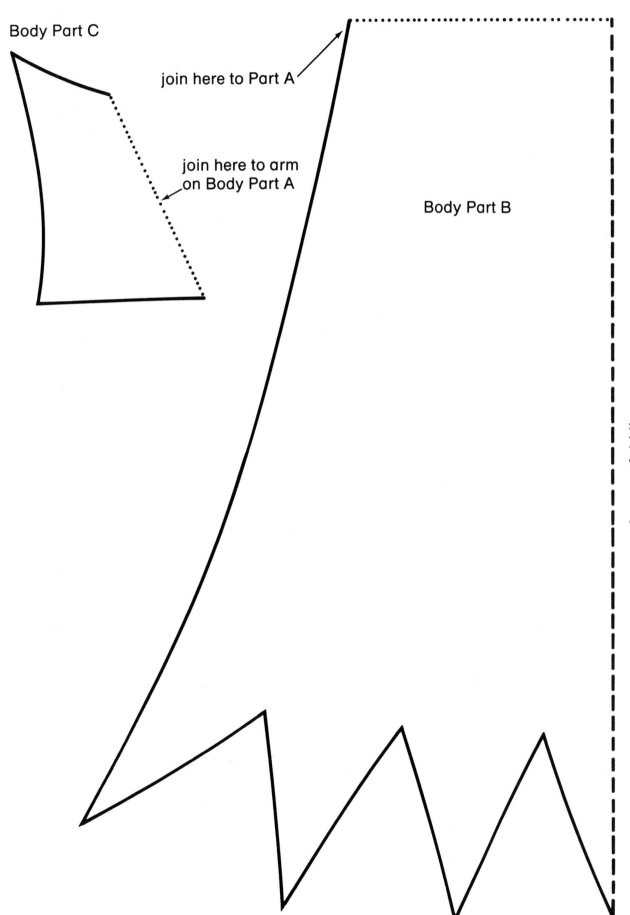

Body Part C

join here to Part A

join here to arm
on Body Part A

Body Part B

place on fold line

Witch Hat Pattern

Art and Writing Throughout the Year © 1989

Witch Mouth, Leg, and Hand Patterns

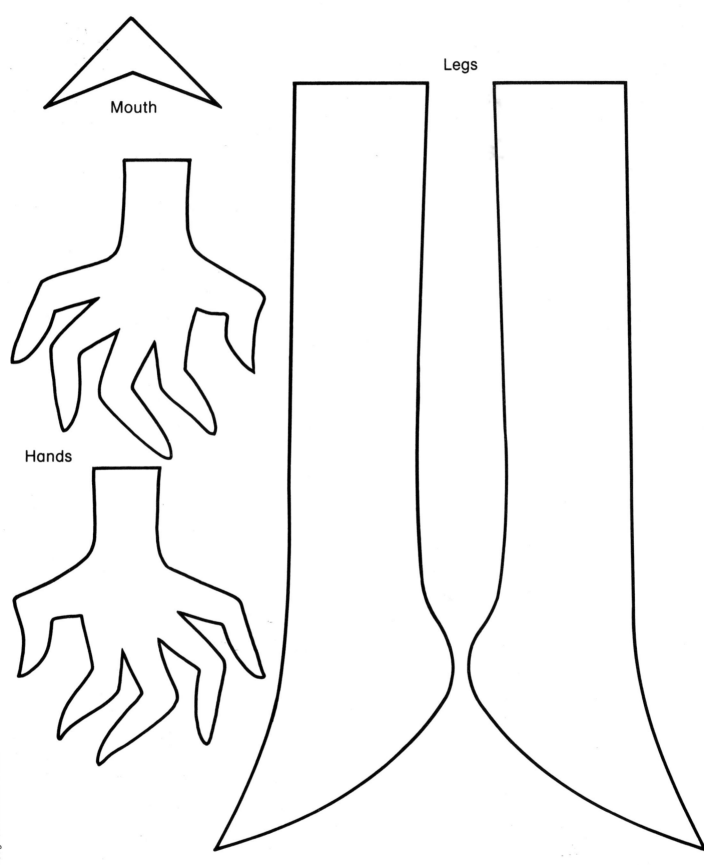

Mouth

Legs

Hands

The Spooky Season

A number of Christmas carols have been rewritten for Halloween. One of the most popular is "The Twelve Days of Halloween." Children can have a lot of fun writing Halloween words to old carols and they are often quite successful at it. However, since Christmas music follows Halloween by only a few short weeks, I prefer to have children write new lyrics for traditional, nonholiday songs.

Using the Unit

Start by helping the children think of familiar melodies that contain repetitive phrasing —nursery and folk songs work well. Then help the children find Halloween words to fit the song. The students may need a few examples to get them started. For example, "Row, row, row your boat, gently down the stream," could become "Boo, boo, boo, the ghost, calls out hauntingly." Or, "There's a hole in your bucket, dear Liza, dear Liza," could become "There's a bat in your cauldron, dear Witchy, dear Witchy."

After practicing with the class, duplicate and hand out the primary or middle-grade writing plans (pages 37 or 38). Ask the children to write out the original words to their favorite songs on a separate piece of paper before they attempt to write new lyrics. Have the children write the final versions of their songs on a clean piece of paper.

If you have the time, duplicate your students' best songs and put them together into a Halloween songbook for your class. (You could also tape the children singing their songs and use this music as background for a classroom Halloween party or for marching music for the traditional Halloween costume parade.)

Once the students have finished their songs, have them make the Pumpkin Heads (page 39). Plan to use the completed figures with Halloween songs, as puppets in Halloween skits, or to decorate the covers of Halloween songbooks.

Spooky Songs

You have probably sung Christmas carols, but have you ever sung a Halloween carol? It's easy to make one up! First sing "Happy Birthday" with your teacher. Then try singing the song with these words:

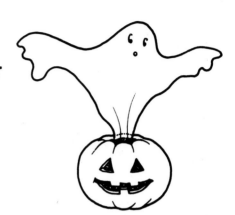

> Spooky Halloween to you!
> A ghost calls out, "Boo!"
> It's haunting and shrieking
> and scaring me, too!

Complete the songs below. Use the rhyming words in the box to help you get started.

boo hoo	blue	new	who
brew	true	into	too
you	chew	view	flew
shoe	do	two	phew

Scary Halloween to you!
Oh, what shall we do?

Happy Halloween to you!
The witch cries, "Boo hoo!"

Take Me Out to the Graveyard . . .

Sometimes you can take an old song and turn it into something new and exciting just by changing the words.

This page will help you write a Halloween song. Pick a song with a simple melody, such as "Take Me Out to the Ball Game," "Happy Birthday," or "Old MacDonald Had a Farm."

What is the title of the song you picked? _____

What is your new title? _____

List several words or phrases that make you think of Halloween.

_____ _____

_____ _____

_____ _____

What are some of the Halloween-theme rhyming words you could use in your song? Think of interesting rhymes such as chew/boo, ghost/boast, or witch/snitch.

_____ _____ _____

_____ _____ _____

Count the number of syllables in each line of the original song. Write the numbers on the line. When you write your song, try to keep the same number of syllables in each line.

Read over what you have written. Then write your song on a clean piece of paper. Do not write a second verse—spend your time making the first verse as good as it can be.

Art and Writing Throughout the Year © 1989

Pumpkin Heads

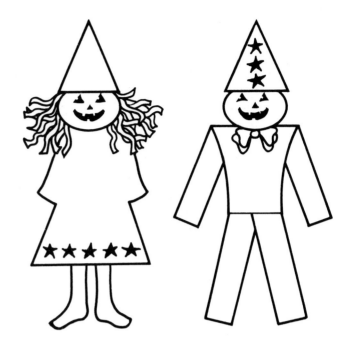

Materials for Pumpkin Heads

- Witch and wizard patterns (pages 40–41)
- Baker's dough (4 cups flour, 2 cups salt, 1 cup water, 4 tablespoons oil)
- Orange paint or food coloring
- Jack-o'-lantern cookie cutters
- Black construction paper
- Crepe or tissue paper in several bright colors
- Cardboard
- Paintbrushes (if using paint)
- Gold star stickers
- Scissors, stapler, glue, and markers
- Roller
- Bowl

Teacher Preparation for Pumpkin Heads

1. Duplicate one copy of the patterns for each child. Staple each pattern page to one piece of black construction paper. (Make sure you staple *outside* the pattern lines.)
2. Mix the ingredients for the baker's dough in a bowl. Knead. If you wish, add orange food coloring. (If you don't, the children can paint the heads with orange paint after the heads have been baked.)
3. Cut the cardboard into 2″ × 6″ strips with a paper cutter. Also cut the crepe or tissue paper into 8″ × ¾″ strips for the hair and bows.
4. Just before the children start, roll the dough for children to cut.

Student Directions for Pumpkin Heads

For pumpkin-head witch:

1. Cut out a head with a cookie cutter.
2. Bake the head at a low temperature until completely dry.
3. If the head is not colored, paint it orange. Let dry.
4. Glue the head 1½″ away from one end of a cardboard strip. (This gives the figures strength so they can be hung or pinned to a bulletin board.)
5. Glue hair to the underside of the head on both sides.
6. Cut out the witch patterns. Cut through both pieces of paper.
7. Glue the legs to the dress. Then glue the hat above the pumpkin head and the dress below the head. Let dry.
8. If you wish, decorate the witch's dress with gold stars.

For pumpkin-head wizard:

1. Cut out a head with a cookie cutter.
2. Bake the head at a low temperature until completely dry.
3. If the head is not colored, paint it orange. Let dry.
4. Glue the head 1½″ away from one end of a cardboard strip.
5. Cut out the wizard patterns. Cut through both pieces of paper.
6. Glue the legs and arms to the trunk. Then glue the hat above the head and the trunk below the head. Let dry.
7. Decorate the wizard's hat with gold stars. Make a bow with two colors of crepe or tissue paper. Glue the bow below the head.

Pumpkin-Head Witch

Dress

Hat

Legs

Art and Writing Throughout the Year © 1989

Pumpkin-Head Wizard

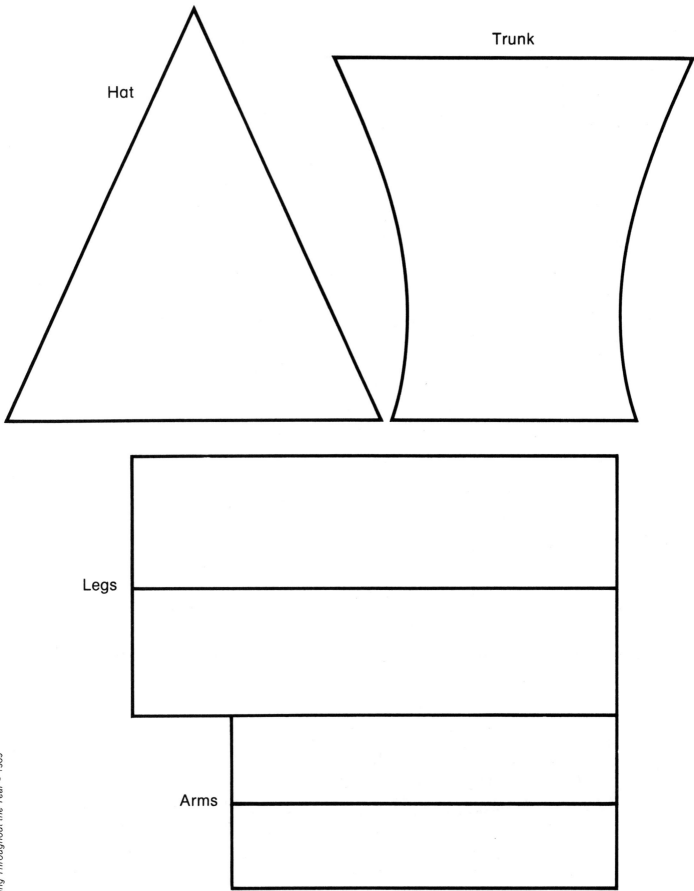

Hat

Trunk

Legs

Arms

Indian Myths and Legends

The study of Native Americans should certainly not be limited to the month of November. However, this is a very popular time for many teachers to focus on the contributions that the first Americans have made to our history and culture. Teaching students about Indians through their art and writing—particulary pictographs and tribal myths and legends—inspires the children to read and write about Native Americans on their own.

Using the Unit

If possible, take the class on a field trip to a natural history museum or an academy of science that has a display of Indian artifacts. If you simply cannot take the class on a trip, many art museums have slide collections that they will loan out to classroom teachers. Use these slides to introduce the children to Indian art and culture.

Introduce the children to Indian myths and legends by reading aloud to them. There are several excellent collections of these myths that can be found in public libraries. Some books concentrate on a particular type of myth or legend, such as creation stories or animal stories. Tomie de Paolo's *Legend of Bluebonnet* is a sensitive, beautifully illustrated myth that can be read to children of all ages.

After you have excited the children's interest in Indian culture, have them write their own stories. For younger children, duplicate and hand out the writing plan and Indian Picture Dictionary (pages 43-44). Explain that the students should use the dictionary page to help them read and write their own picture stories. (They can draw their own symbols if they wish; however, they should be sure to add these to their dictionary pages.) Go over the directions carefully, making sure that the children understand what they are supposed to do. Allow plenty of time for this project.

Use the Indian Myth writing plan (pages 45-46) with the older children. Make sure the students work in pencil, so they can change details as they go along and correct errors easily. The students may keep these pages to work from, since the plans are simply to help students organize their thoughts. The final myths should be about a page long. (I usually collect the finished myths and assemble them into a class book each year. The best stories are read to children in succeeding years.)

Make sure you collect the materials for the Shadow-Box Weavings (page 47) well in advance of beginning the project. You should also do a weaving yourself before introducing the project to the class so you will anticipate any problems that might occur. When you set up the display, have the children make "Artist Cards" on 3″ × 5″ index cards. Each card should contain a child's real name and his or her chosen Indian name. For example, one card might read "WEAVER: She Who Loves Rabbits (Mary Jones)." Place the cards next to the displayed weavings.

An Indian Picture Story

Sometimes the Indians used pictures instead of words. Read the picture story below. (Use the picture dictionary to help you.) Then write an ending to the story on scratch paper. Rewrite the ending on the lines below, using pictures as well as words.

A long time ago, when the were at , a lay in the . It loved the __•__ |||||| weather.

Suddenly, the appeared. " ," it said, "I need your ☒ . My enemy, the is coming. If the arrives, there will always be |ʃ ʃ ʃ| and ⌒ɛɛɛ⌒ ."

"Of course I will help," said the . "But what do you want me to do?"

Art and Writing Throughout the Year © 1989

Indian Picture Dictionary

clear
weather

rain

snow

lightning

winter

spring

summer

water

mountains

star

sun

moon

good

bad

happy

sad

braves

teepee

turtle

war

peace

help

eagle

horse

bear

Great Spirit
Everywhere

Thunderbird

An Indian Myth

You are about to write an Indian myth of your own. These pages are writing plans. Use them to make decisions as you plan the content and organization of your story.

What will your myth explain? For example, will it explain how people or animals learned to do certain things, why certain events take place every year, or why people or animals look or act the way they do? Be specific.

Will there be animal characters in your myth? If so, include their names and descriptions.

Name Description

_____ _____

_____ _____

_____ _____

_____ _____

Will there be human characters in your myth? If so, include their names and descriptions.

Name Description

_____ _____

_____ _____

_____ _____

_____ _____

An Indian Myth (continued)

Where does the story take place? Make a list of words or phrases that describe the place or places where it all happens.

What is the title of your myth? (Be sure to include the word *how* or *why* in your title.)

When you are finished, reread what you have written. Add details where you think they are missing. Cross out ideas that you don't think will work. Hand in your plan and begin your myth.

Art and Writing Throughout the Year © 1989

Shadow-Box Weaving

Materials for Weavings and Frames

- Adult-size sturdy shoe boxes (one for each child)
- Tagboard: white, gray, or light blue
- Yarns and unspun wools in neutral tones
- Thin, smooth cord (for warp)
- Rulers, scissors, markers or crayons, and pencils
- Dyed salad macaroni (optional)
- Feathers or dried flowers (optional)
- Mat knife (for teacher)

Teacher Preparation for Weavings and Frames

1. Cut eight ½"-deep slits, evenly spaced, on opposite ends of the boxes.

2. Knot one end of the smooth cord and slip the knot through one of the end slits. Make sure the knot is on the inside of the box. Thread the cord back and forth through the slits to form the warp. Tie a knot at the end of the cord. Make one box for each student. (You might have older children do this for themselves.)

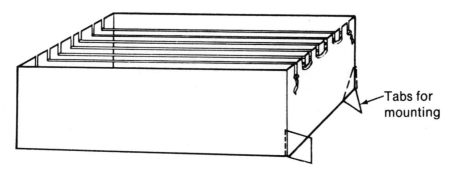

Tabs for mounting

3. Cut diagonal slits across two back corners of the box. Slit along the sides and then fold out. These tabs will make mounting the weavings on the wall easy.

4. Cut the tagboard pieces in half so you have pieces that are 14″ × 22″. Use one piece to make a frame template. Cut out a 4″ × 10″ section in the center of the tagboard. Also cut out border design spaces as shown:

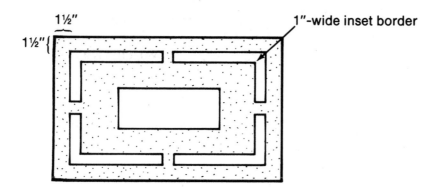

5. Trace around the center and border design spaces on the other pieces of tagboard. Cut out the centers for the children.

Student Directions for Weavings and Frames

1. Choose the yarns you wish to use.

2. Weave the yarn through the cord on your box. You might try using a card or pencil to hold up the cord strands while you weave. (Note to teacher: Help the children weave back the dangling ends when they want to change yarn.)

3. If you wish, work macaroni, beads, feathers, or dried flowers into the weaving. However, use these sparingly.

4. Decorate your frame. To do this, divide the border areas into 1″ squares (use a pencil to do this). Then make triangle designs within each square. Or use Indian pictographs. Make your designs symmetrical. Color in the triangles after you are pleased with your design.

Materials for Assembly and Display

- Con-Tact paper or hot-glue gun
- Masking tape, wire, or yarn

Teacher Directions for Assembly and Display

1. To attach weaving to frame, place decorated frame face down and then center the weaving over the frame opening. Use Con-Tact paper as you would a thick strip of tape or hot glue to attach the box to the frame.

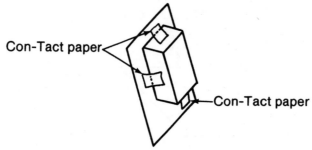

2. To display the weavings, tape across the tabs or pin them to the wall.

3. Arrange the weavings on a wall asymmetrically.

The Pilgrims

Most children are first introduced to American history by the story of the Pilgrims and the first Thanksgiving. The writing plans in this unit focus on what it would have been like to be a Pilgrim and the middle-grade writing plan involves creative log or journal writing. I feel that journals are an indispensible part of any good writing program, and that *creative* journal writing, in particular, is a good way to introduce the concept of journal writing to the class.

The Pilgrim Paper Sculptures make attractive decorations at any Thanksgiving feast. Do the art project early so that children can take the paper sculptures home on Thanksgiving.

Using the Unit

Have the class make the Pilgrim Paper Sculptures (page 54). You should make the figures yourself before attempting to explain the directions to the children. Tying ribbons and attaching hair to the figures requires some dexterity! To individualize the figures, have your students style the hair in different ways. You might also design your own patterns so the figures can carry different objects that are representative of the types of chores Pilgrim children had to do or the toys with which they played.

For younger children, duplicate and hand out The First Thanksgiving writing plan (page 50). Have them choose their favorite ending to each of the four sentences on the page. Then have them complete the stories with their own ideas. When the children have finished their rough drafts, ask them to write their final drafts on a clean sheet of paper.

For older children, duplicate and hand out the middle-grade writing plan (pages 51–53). Explain the concept of journal writing. Point out that the journal entries should be creative—they do not have to be entirely accurate in terms of historical detail. However, the children should try to imagine themselves in each situation and write entries that contain the thoughts and descriptions of a real person in those situations. The students may refer to their plans when they write their entries.

The First Thanksgiving

It is the morning of the first Thanksgiving. You and your brother Zeke are helping your parents get ready for the meal. Tell the story of that first feast.

Look at the sentences below. Each sentence has two endings. Circle one to end each sentence. Then write the sentences on the lines. Write more sentences to finish the story.

1. Thanksgiving morning was cold and clear.

 cloudy, but warm.

2. Zeke and I helped out by getting water from the river.

 chopping nuts for bread.

3. After the chores, we played hide-and-seek.

 went to the beach for shells.

4. Finally, it was time to sit down and eat.

 help serve the food.

Art and Writing Throughout the Year © 1989

A Pilgrim's Journal

A ship's log is a record kept by the ship's captain. It tells all that happens when a ship goes on a journey.

Pretend you are the captain of the Mayflower. It is your job to write detailed entries in the log. Remember, the people reading your log are in England, so be descriptive.

Entry 1: The day the ship lands in Massachusetts. December, 1620.

What time of day is it when the ship lands? What is the weather like?

List several words or short phrases that describe what the coast looks like.

_____ _____

_____ _____

_____ _____

What is the mood of your passengers, the Pilgrims?

List four things that happen when you land.

1. _____

2. _____

3. _____

4. _____

A Pilgrim's Journal (continued)

Describe what happens when the first person steps off the ship.

Entry 2: Plymouth, Massachusetts. Fall, 1621.

A tribe of Indians called the Wampanoags have taught the Pilgrims how to grow corn and how to catch the local fish. Now that the crops are ready to be harvested, the Pilgrims have invited the Indians to share a Thanksgiving feast. You have just finished eating, and are writing your entry by candlelight.

Where was the feast held? What did the place look like?

Describe the food that was served.

_____ _____

_____ _____

_____ _____

What were the Wampanoags like? What did they wear? What did they bring?

What did the Pilgrims and Wampanoags talk about?

Art and Writing Throughout the Year © 1989

A Pilgrim's Journal (continued)

How did the Pilgrims' and Wampanoags' moods change during the feast?

Entry 3: Plymouth Bay. Spring, 1622.

You have just left the colony to return to England. What does the coast look like now?

How have your feelings about the Pilgrims changed during your journey with them?

List several words or short phrases that describe how you feel about leaving the new colony.

_____ _____

_____ _____

_____ _____

When you have finished, reread what you have written. Add details where you think they are missing. Then write the three journal entries on clean pieces of paper. Remember to date the entries.

Art and Writing Throughout the Year © 1989

Pilgrim Paper Sculptures

Materials for Pilgrims

- Patterns (pages 56-64)
- Construction paper: white, beige, and gray
- Tagboard, cream colored
- Thick yarn: yellow, brown, and russet
- Silver foil tagboard or silver marker for hatchet (optional)
- Stick pretzels for cut wood (optional)
- White pipe cleaners for cauldron handles (optional)
- Black yarn for collar tie
- Markers, scissors, and glue

Teacher Preparation for Pilgrims

1. Duplicate the figure patterns, cut out, and assemble as indicated on pattern. Trace around the completed figure on pieces of tagboard. Make one tagboard figure pattern for each child.

2. Duplicate the rest of the patterns on colored construction paper. Use beige paper for the faces; white paper for the cuffs, collars, girl's hat brim, apron, and waistband; gray paper for the remaining patterns.

3. Separate the Pilgrim girl and boy patterns and place them in individual packets for the children. Make a few extra of each type. (Some girls may want to make the Pilgrim boy and some boys may want to make the Pilgrim girl.)

4. Cut the different colors of yarn for hair.

Student Directions for Pilgrims

For pilgrim girl:

1. Cut out the figure and face. Color the eyes and mouth on the face.

2. Glue the face to the front of the figure. Then glue the hair on the outside of the face. Let dry, then style the hair.

3. Cut out the clothing pieces.

4. Glue the front bodice and skirt to the front of the figure. Then glue the front hat and apron to the figure. Make sure you only glue the top part of the apron so the bottom is loose. Glue on the hat brim.

5. Glue the back bodice and skirt to the back of the figure. Then glue the back hat, back collar, back waistband, and cuffs to the figure. Let dry.

6. Use a small piece of black yarn to make the collar tie on the front.

7. If you wish, make the girl's cauldron. Cut out the cauldron pattern and color it black. Bend a small piece of white pipe cleaner to make the handle. Glue the two ends of the pipe cleaner in between the folded cauldron pattern. Glue the handle to the girl's hand.

For pilgrim boy:

1. Cut out the figure and face. Color the eyes and mouth on the face.

2. Glue the face to the front of the figure. Then glue hair on the outside of the face. Let dry.

3. Cut out the clothing pieces.

4. Glue the front pants to the figure.

5. Assemble the front jacket. Fold along the broken line on the right side of the jacket. Then glue the folded tab area on the left side of the jacket. Glue the completed jacket to the figure.

6. Color the belt pieces and the hatband areas of the hat black. Glue the front of the hat and the belt to the figure.

7. Color the inside square of the belt buckle black. Glue the buckle to the belt.

8. Glue the front collar in place.

9. Color the "shoes" of the figure black.

10. Color the back of the figure's head to match the hair color.

11. Glue the back pants and then the back jacket to the figure.

12. Glue on the back hat, back belt, and back collar.

13. If you wish, make the boy's ax and wood. Color the ax handle black. Use silver foil or a silver marker on the ax head. Glue the ax to the boy's hand. Glue several stick pretzels for wood in the other hand.

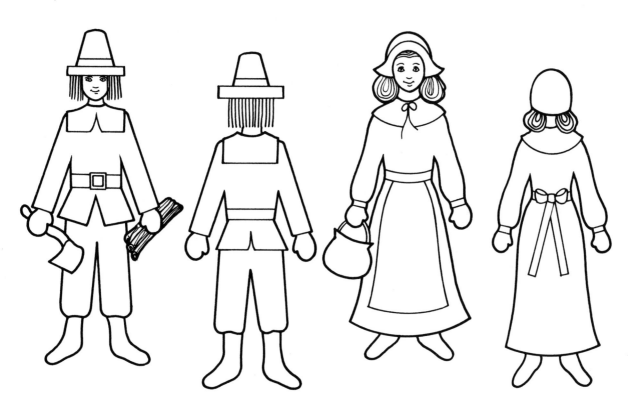

Pilgrim Figure Pattern

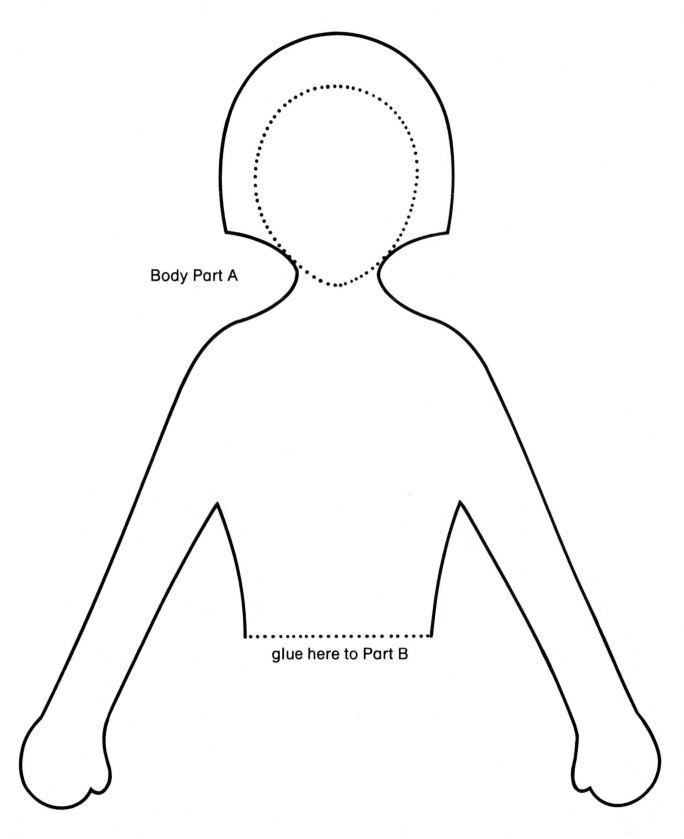

Body Part A

glue here to Part B

Art and Writing Throughout the Year © 1989

Pilgrim Figure and Face Patterns

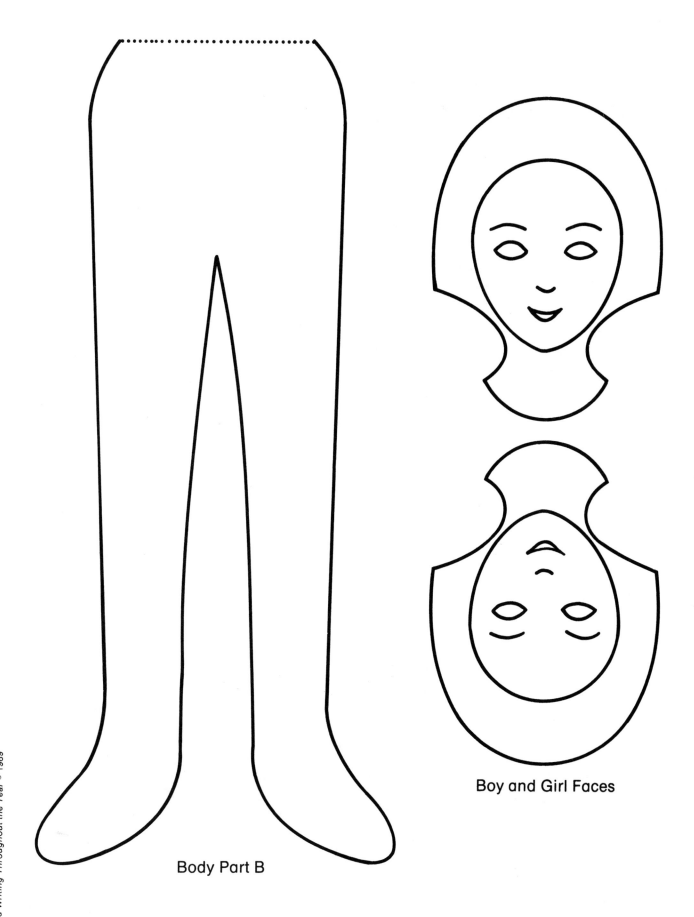

Body Part B

Boy and Girl Faces

Pilgrim Patterns

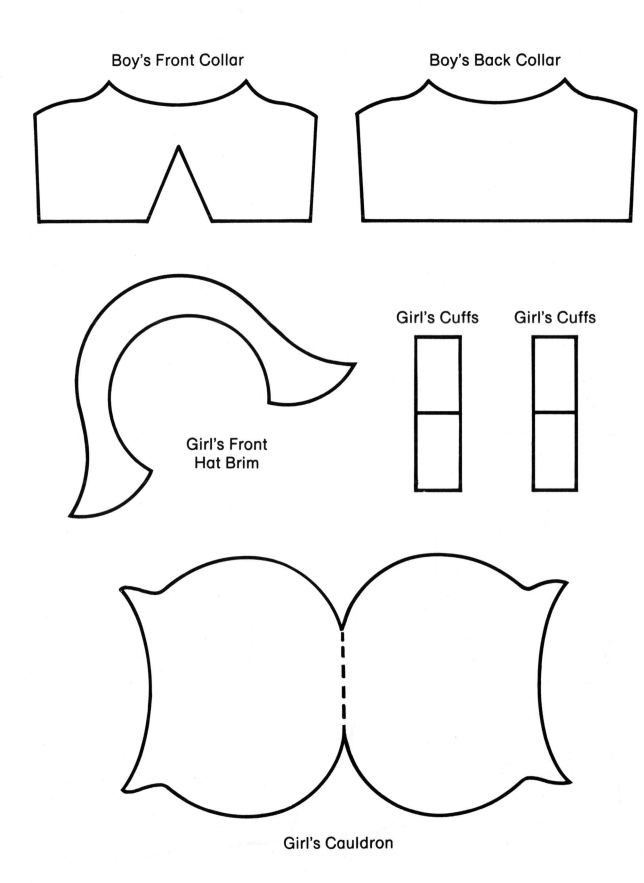

Boy's Front Collar

Boy's Back Collar

Girl's Front Hat Brim

Girl's Cuffs

Girl's Cuffs

Girl's Cauldron

Art and Writing Throughout the Year © 1989

Pilgrim Patterns

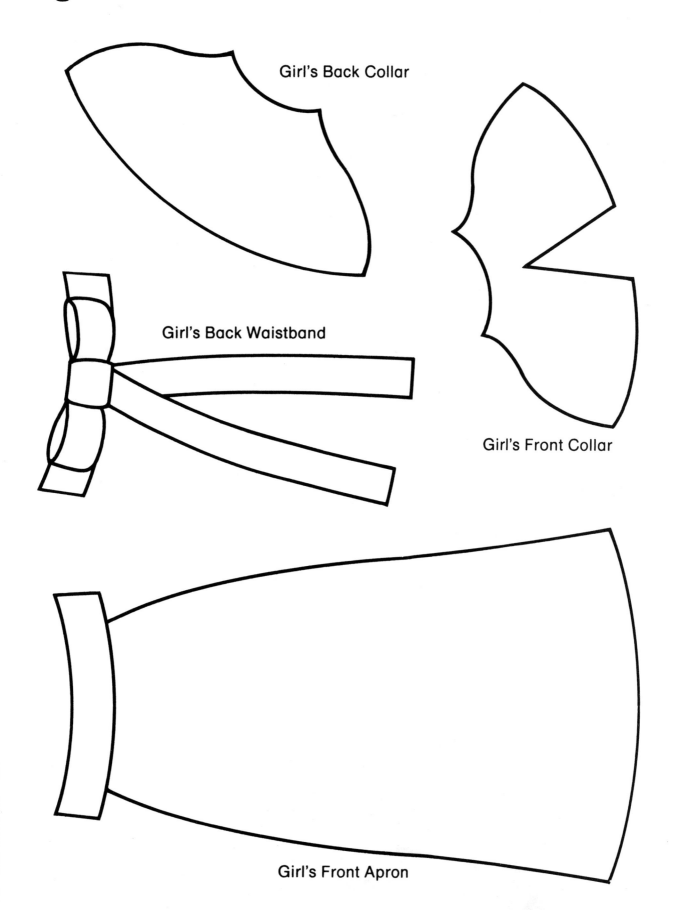

Girl's Back Collar

Girl's Front Collar

Girl's Back Waistband

Girl's Front Apron

Pilgrim Patterns

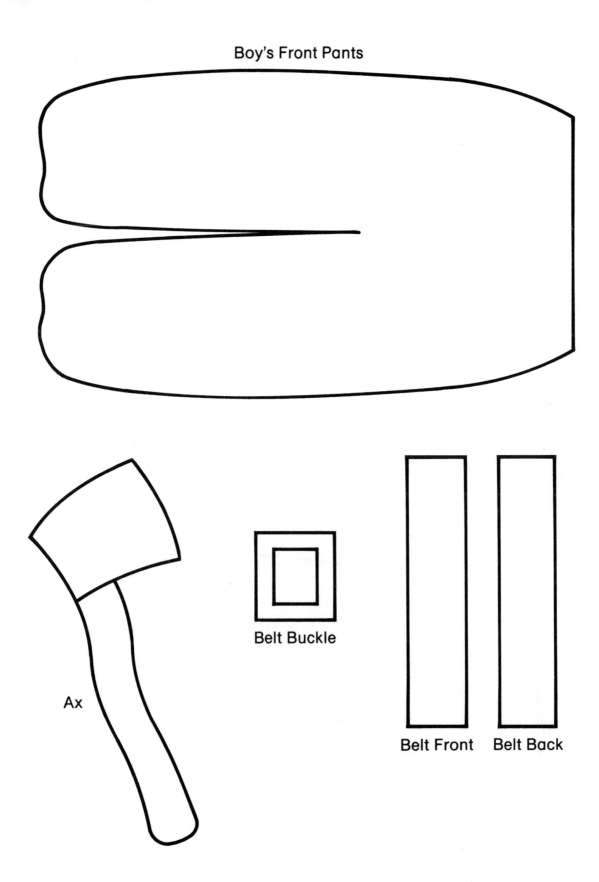

Boy's Front Pants

Ax

Belt Buckle

Belt Front Belt Back

Art and Writing Throughout the Year © 1989

Pilgrim Patterns

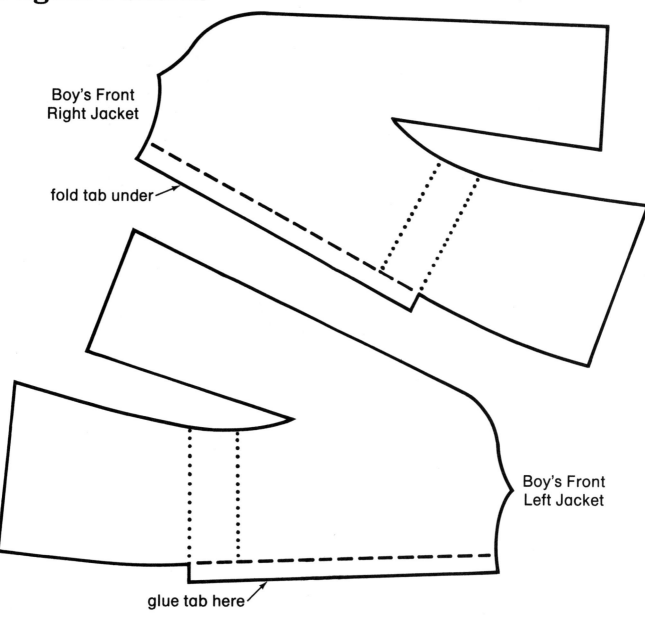

Boy's Front
Right Jacket

fold tab under

Boy's Front
Left Jacket

glue tab here

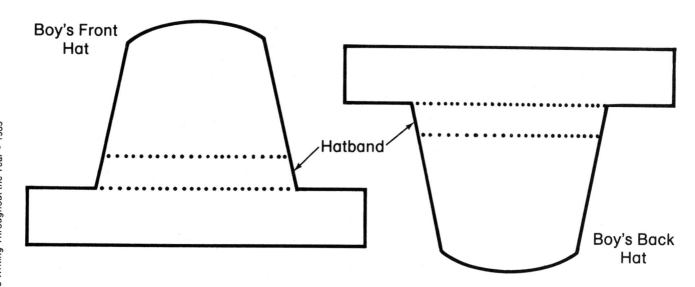

Boy's Front
Hat

Hatband

Boy's Back
Hat

Pilgrim Patterns

Boy's
Back
Jacket

Boy's
Back
Pants

Pilgrim Patterns

Art and Writing Throughout the Year © 1989

Pilgrim Patterns

Girl's Front Bodice

Girl's Front Hat

Girl's Back Bodice

Girl's Back Hat

Pilgrim Patterns

Girl's Front Skirt

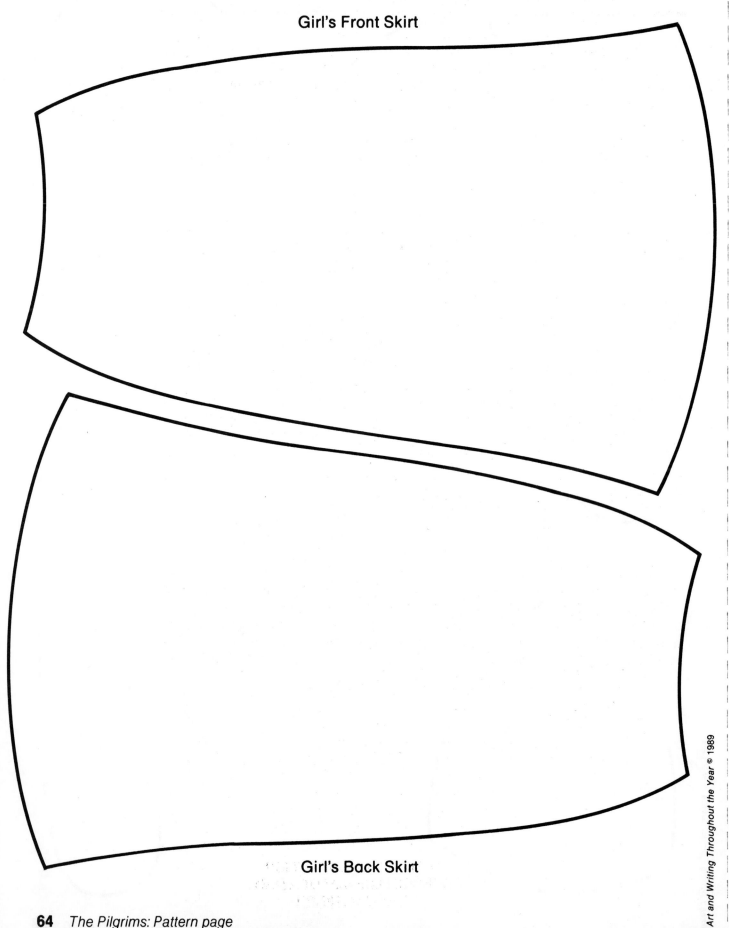

Girl's Back Skirt

Christmas in Other Lands

Though a very exciting month for children, December is usually a short school month. I try to do one project early in the month, display it, and then let the children wrap it up the last week as a gift to take home for the holidays. The Angel Luminarias make particularly good gifts. They incorporate the Mexican punch art technique using gold foil tagboard.

I also use the luminarias to introduce Mexico's Christmas celebration. In my school, we put on a posada (a Mexican Christmas procession). Hall lights are turned off or dimmed, and the children proceed carrying flashlights. (In Mexico, they would carry candles.) Flashlights are also placed behind the luminarias so the light shines through the punched holes. Two children, one girl and one boy, lead the class and everyone sings carols in Spanish. The students walk from room to room, where they are refused entrance at all but one door. Finally, the class enters that last door to share dried fruits and buñuelos (an inexpensive and delicious treat of fried tortillas covered with cinnamon sugar [see recipe on page 201]) with the hospitable class.

Using the Unit

Discuss other countries' Christmas celebrations. If you can, show younger children pictures of Santa as he is seen in other countries. Then duplicate and hand out the Snacks for Santa primary writing plan (page 66). (This writing plan fits in well with a primary cooking lesson. If there is no time for cooking, tasting is also fun! Plum pudding, for example, will be a new taste treat for many primary students.) When the children write their notes to Santa, do not guide them too much. One recipe might read: "Mix three bowls of butter and one sack of sugar. Add chocolate chips. Put it in a pan in an oven. Cook at 10 degrees for 1000 minutes." This probably wouldn't make a delicious cake, but it's a lot of fun to read!

Duplicate and hand out the Holidays in Other Lands writing plan (pages 67-69) for older children. Emphasize that only one of their resources may be an encyclopedia. The final essay should be about one or two pages long.

Plan to spend at least two full periods on the Angel Luminarias (page 70). Show the children how to work out their design elements before you show them a completed model of the punched luminaria. Talk to them about symmetry and have them practice drawing symmetrical designs. Point out that students who have drawn butterflies or made the Indian Shadow-Box Weavings (page 47) have already worked with the principles of symmetry. Have the children help each other, working in pairs or even small groups, as they plot their designs. Also have students practice punching scraps of gold tagboard before they punch out the designs on their angels.

Snacks for Santa

Children all over the world leave snacks
for their Santa to eat on Christmas Eve.
Pretend you live in another place. What
would you leave for Santa? Use the
menu below to help you decide. Then
write a note telling Santa about the
snack you have left. Write the recipe in
your own words.

MENU	
mince pie	julgröt (rice pudding)
plum pudding	bûche de noël (Christmas cake)
apples and dates	buñuelos (fried pastries)
lebkuchen (spicy cakes)	stollen (fruit-filled bread)
panettone (Christmas bread)	

Dear Santa,

I am leaving you a special snack. It is called _____

This is how I made it. (_____ helped me.)

Recipe: _____

Mix _____

Add _____

Put _____

Cook at _____ degrees for _____ minutes. Then enjoy!

Love,

Art and Writing Throughout the Year © 1989

Holidays in Other Lands

Every country has its own special holidays. Some places celebrate special events in the development of the country; others celebrate the same holidays that we do, but in different ways.

What are some holidays that are celebrated in other countries but not in the United States? What are some holidays that are celebrated throughout the world in different ways? Choose one country and holiday that you would like to investigate. Find several sources of information that tell about that country's holiday celebration. Write down the book titles, authors, and pages for a bibliography. (Only one source may be an encyclopedia.)

Your chosen country: _____

Your chosen holiday: _____

What event does the holiday celebrate? Is it celebrated in other places? On which day or days is the holiday celebrated?

Investigate the history of the holiday. When was it first recognized as a holiday? Who were the first participants? Where did the first celebration take place?

_____ _____

Art and Writing Throughout the Year © 1989

Holidays in Other Lands *(continued)*

How has the holiday changed over the years?

Are special foods prepared for this celebration? If so, what are they?

If you can, try to find a recipe for one of the foods eaten during the celebration. List the ingredients. Then write the directions for making it.

Are any songs sung during this holiday? If so, what type of songs are they? Are any of the songs similar to the songs that we sing?

Art and Writing Throughout the Year © 1989

Holidays in Other Lands (continued)

List any other traditions (games, processions, religious observances) that occur during this holiday celebration.

1. _____
2. _____
3. _____
4. _____

Would you like to see this holiday celebrated in the United States? Explain your opinion.

List your sources of information.

1. _____
2. _____
3. _____
4. _____

Reread what you have written. Look for the best way to put your information together into a report about your holiday.

• Joyeux Noël • • Sheng Dan Kuai Le • • S Rozhdestvom Kristovym •
• Kala Christougenna • • Merry Christmas • • Glaedelig Jul •

Art and Writing Throughout the Year © 1989

Angel Luminarias

Materials for Angel Luminarias

- Patterns (pages 73–75)
- Design Practice and Pattern Page (page 72)
- Gold foil tagboard (available in art supply stores)
- Gold spray paint
- Large, sharp needles
- Scissors, rulers, and Scotch tape
- Pencils: red and black

Teacher Preparation for Angel Luminarias

1. Duplicate one copy of the patterns to use as a template. Cut out the patterns. Join the body patterns together as indicated. Trace around the completed body and head patterns on the back sides of the gold tagboard. Use sharp scissors or a knife to score the fold lines. Make one set of patterns for each child.

2. Use gold spray paint to color the back sides of several pieces of gold tagboard. Use these pieces to make the arm patterns. Trace around the arms on the painted side of the board once the paint has dried. Score on the fold lines.

3. Duplicate the Design Practice and Pattern Page. Make lots of extras, children may need them.

4. Make your own angel before the class does so you can anticipate any problems your students might have.

Teacher Directions for Lessons for Angel Luminarias

1. Have students cut out the tagboard pieces. Have them place these to one side until they have finished their designs.

2. Have children practice designs for the angel's skirt. Demonstrate simple symmetric, geometric designs on the chalkboard. Tell the students to use straight lines only—not curves. Have the children work from the midpoint of the skirt out and tell them that each time a shape is drawn on the left it should be repeated on the right. Then have the students draw, in pencil, designs on the Design Pattern Page.

3. Have children practice designs for the angel's wings. Again, demonstrate the designs on the chalkboard. The wing designs should be one repeated pattern of shapes and both wings should be identical. Have students start at the outer edge of each wing and work in. Remind them that each time a shape is drawn on the left wing, it should be repeated on the right.

Art and Writing Throughout the Year © 1989

4. Have the students go over their designs and mark the places where holes will be punched with a red pencil. Punched holes should be at the ends of lines, intersections of lines, and the corners of geometric shapes.

5. Check the students' designs.

6. Help students position and tape their patterns to the backs of the angels' wings and skirts.

7. Have children begin punching. They should carefully stick large needles through the patterns and tagboard where they have marked red dots. Watch to make sure that the procedure is understood. Missed holes are easier to see from the front, so children should periodically check the front of the angel while they work. Check the final work, then let the children carefully remove the patterns.

8. Fold the body so it stands by itself.

9. Have children fold and tape the arms to the shoulders of the angels. They should tape the hands together with a small piece of Scotch tape on the underside of the hands.

10. Have the children tape the faces to the angels with a small tape circle. (Glue causes lumps.) Students should *not* draw faces on the angels.

Design Practice and Pattern Page

Art and Writing Throughout the Year © 1989

Angel Luminaria Patterns

score and fold
towards face

Body Part A

join here to Part B

join here to Part C

score and fold away from face

Angel Luminaria Pattern

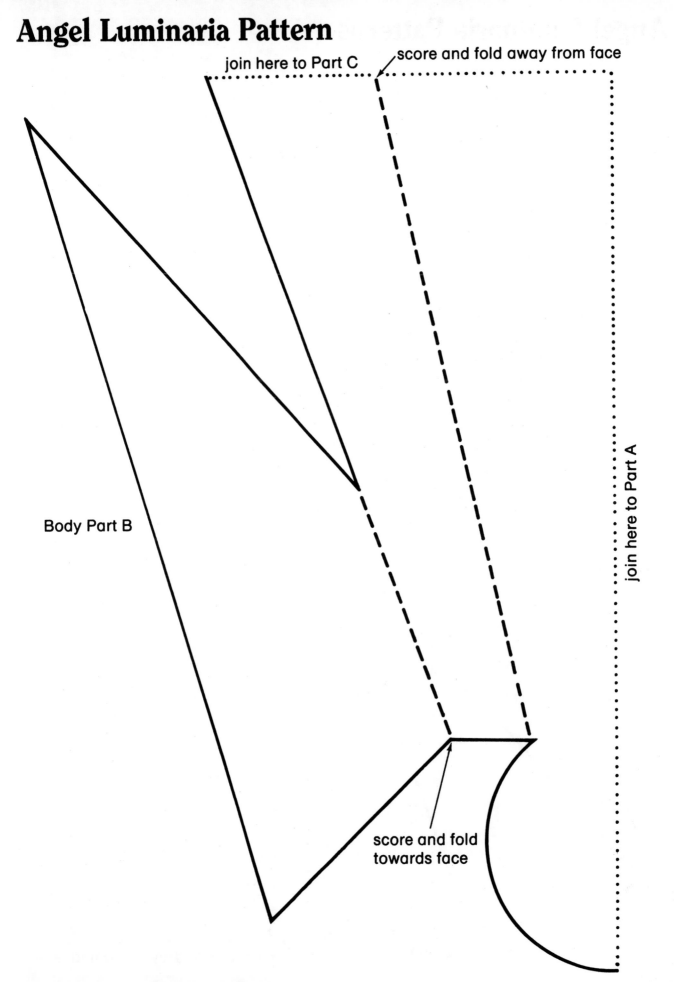

join here to Part C

score and fold away from face

Body Part B

join here to Part A

score and fold towards face

Angel Luminaria Pattern

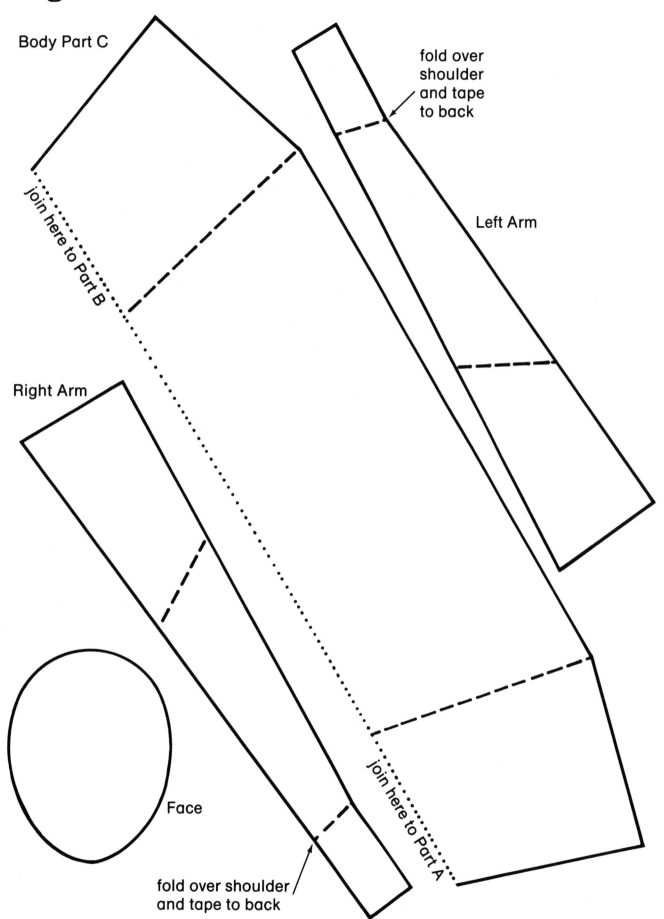

Body Part C

fold over shoulder and tape to back

Left Arm

join here to Part B

Right Arm

Face

join here to Part A

fold over shoulder and tape to back

A Dancing Santa of Many Moods

December in American schools is often a magical time for children. Music is taught almost daily, art two or three times a week, and plays and pageants are performed. Such a burst of creative energy can often lead to frenzied classrooms and frazzled teachers. However, since December is such a special month for children, it might be a fine month to put on a dramatic production in your classroom.

The Dancing Santa of Many Moods play for older children needs only simple costumes and props—a Santa's hat and an apron will suffice. Write your own composite second act from the set of student acts for the children to perform, or have a class vote to choose one or two of the students' individual second acts. Try performing this play for a younger class in the school.

Younger students can use their Dancing Santa Puppets to act out Santa's various moods. You could either call out different moods and have the children position their puppets to fit the mood or you could call out different situations, such as those on the writing plan, and have the students decide what mood their Santas would be in for each situation. Students can also invent dialogue on the spot and perform in short puppet shows for each other.

Using the Unit

For younger children, duplicate and hand out the plan for Santa's Many Moods (page 77). After children have completed writing, ask them to choose their best sentence to put on a construction paper strip. Have them use colored pencils or crayons to print their sentences on the strips. Then have them make the Dancing Santa Puppets (page 83). Show the children how the position of the Santa's arms, legs, and head affects their perceptions of the Santa's mood.

After using the puppets to dramatize different moods, display the puppets and the sentence strips on a Christmas bulletin board.

Tell older students that they will be writing their own scenes for a Christmas play. Duplicate and hand out the Dancing Santa of Many Moods play and writing plan (pages 78–82). (Note: This writing plan is intentionally less structured than the other plans in the book.) Show the children how to underline the names of the characters who are speaking and how to write stage directions for the characters in parentheses. (Viola Spolin's book on theater games is a marvelous resource for teaching children drama.)

While the class is working on their plays, you can also have them make the Dancing Santa Puppets. For these older children, the puppets are intended to be used as gifts for younger siblings or as Christmas tree decorations. The puppets are not part of their plays.

Santa's Many Moods

Santa's moods can change just like
yours do. He can be excited, angry,
worried, happy, and even proud. Imagine
how Santa would feel in each of the
situations below. Then write a sentence
that describes what Santa's mood might
be like for each event.

The day before Christmas _____

When he slides down a chimney _____

When he receives a thank-you note from a child _____

When a toy breaks _____

The day after Christmas _____

On a hot day in the summer _____

A Dancing Santa of Many Moods

A PLAY AND WRITING PLAN

CHARACTERS

Santa Claus	Sunshine	Jee Yeon Lee, age 5
Mrs. Katharine Claus	Mercurial	Jose Martinez, age 6
Grouchy	The Talking Tree	Karen Kamei, age 7

Setting

This play takes place at the Emporium (a large downtown department store in San Francisco) and at Santa's Workshop in the North Pole. Santa has sent Grouchy and Sunshine to represent him at the Emporium. Grouchy is in the 5th-floor Wonderland and Sunshine is in the 2nd-floor Toy Department. Mercurial supervises both Grouchy and Sunshine, filling in for them at lunchtime and calling in their toy orders each hour to the North Pole.

Scene One

The problem is introduced. Santa is worried about the inadequate training his helpers have had this year. Because Santa was so busy, the Santa School course was shortened. He is concerned that some of its graduates, especially Grouchy, should have had more training. Santa and Mrs. Claus discuss the situation.

Scene Two

The setting changes from the North Pole to the Emporium. Jee Yeon crawls into "Santa's" (Grouchy's) lap and both of them tumble backwards. What happens next? You are the playwright. Remember to include each of the children, all three helpers, and the Talking Tree.

Scene Three

It is December 26. Santa, Mrs. Claus, and Santa's helpers are drinking tea together—reminiscing about this Christmas and Christmases past.

A Dancing Santa of Many Moods (continued)

SCENE ONE: THE NORTH POLE

(Mrs. Claus is stirring up a batch of fruitcake. When Santa talks to her, she stops stirring and listens attentively. Santa is hammering on a block of wood. When Mrs. Claus talks to him, he pauses and holds his hammer still.)

Santa Katharine, I'm quite worried about Grouchy working on the fifth floor. I don't think he's really ready to make Christmas calls for me. (Santa puts down his hammer and paces back and forth.) Think of him sitting in my chair holding children on his lap all day. You know that some children are shy and need to be listened to patiently. Does Grouchy know how to be patient? I don't think so! I'll never learn what they really want for Christmas. He'll frighten the children into saying the first thing they can think of so they can get off his lap. I'll spend all my time making toys that end up in the closet on December 26. That's *not* what my Christmas work is supposed to be about! (Santa stomps his foot in disgust.)

Mrs. Claus There, there, dear, calm down. (Mrs. C. puts down her bowl and spoon and walks over to Santa to pat him on the back.) You know you *need* Grouchy's help. You simply can't be everywhere at once. So many children visit the Emporium each year with their parents. If there is only one Santa's helper, they have to wait in line for hours and they get tired, hungry, and cranky.

Santa Yes, I know. (Santa walks to a pile of toys stage left and begins loading them into a sack. Mrs. C. resumes stirring her fruitcake, adding a few raisins to the bowl.) Well, at least Sunshine is there on the second floor. He's so kind and so patient that children open their hearts to him immediately.

Art and Writing Throughout the Year © 1989

A Dancing Santa of Many Moods *(continued)*

Mrs. Claus That's right, I think Sunshine was born with fine natural listening skills, which were polished by you in Santa School, dear. You can be proud of your work with Sunshine. And remember, Mercurial is also there to supervise and to call in the toy orders, so you can stop worrying. (Mrs. C. walks over closer to Santa.) What's that you're doing now, dear? Can I help?

Santa (Santa spills all the toys out of the sack onto the floor.) Mercurial! I forgot that Mercurial has been assigned to the Emporium, too! Now I have a right to be worried. Mercurial has always been unreliable. As supervisor, he'll have to take over for Sunshine and Grouchy at lunchtimes and you never know what kind of mood he'll be in. If a child sits on his lap and pulls his beard or cries for mother, who knows what he might say! Katharine, I've been too short-handed and too busy this year. I didn't take the time to really teach the Santa students all they needed to learn in Santa School.

Mrs. Claus (She takes Santa's hand.) You've always been a good teacher, Santa. It is too bad your course had to be shortened this year. So many children sent in requests for toys, what else could we do? Every gift needs your attention in the making. Yours is the magic touch of Christmas.

Santa Oh, Katharine, you always know just what to say to cheer me up. You're right, of course. I do need help and Sunshine is such a nice fellow. I'm sure the others . . .

Mrs. Claus Of course, Santa, the others will figure out what to do. If they don't, the children will help them. Surely even Grouchy could not resist the gentle hug or hopeful request of a trusting five-year-old?

Art and Writing Throughout the Year © 1989

A Dancing Santa of Many Moods *(continued)*

 SCENE TWO: THE EMPORIUM

(Five-year-old Jee Yeon Lee has just crawled into Grouchy's lap. She is frightened, but excited. She reaches up to touch his beard when, quite by accident, she knocks his red cap off onto the floor. Grouchy reaches out for the cap and tumbles off his chair onto the floor. His first words to Jee Yeon are . . .)

Scene Two should be written on binder paper. Write the name of each character that is speaking on the left-hand side of the dialogue and underline the name. Try to include all the characters, except Santa and Mrs. Claus, in your scene. Write the directions for movement and use of props in parentheses.

Use the space below to plan where your actors should stand at the beginning of the scene. Draw them in the space.

A Dancing Santa of Many Moods *(continued)*

 SCENE THREE: THE NORTH POLE

(Santa, Mrs. Claus, Grouchy, Mercurial, and Sunshine are sitting together at a festively set table. They are drinking cinnamon tea and eating frosted sugar cookies. Both Santa and Grouchy are soaking their feet in a tub of warm water. They are sharing the same tub.)

Grouchy Only 364 more days, Santa. I never thought I'd say this, but if you don't let me help out next year, I'll be sorely disappointed.

Santa I never thought I'd hear you say those words, Grouchy. If you want to work, I'd be pleased to have the help. You learned a great deal from the children this year.

Sunshine Mercurial, you were a great help to me. Will you volunteer to help Santa again next year?

Mercurial I certainly will, Sunshine. These last few days have been the happiest days of my life. I hardly remember being a child myself. The children I met this Christmas taught me how to laugh, how to play, and how to sing!

Mrs. Claus Let's all sing together now!

Grouchy I'm sorry, Mrs. Claus, I don't think I'll know the words . . .

Ms. Claus Don't be silly Grouchy, everyone knows this one. Just take my hand. (They all hold hands around the table.)

Everyone We wish you a Merry Christmas, We wish you a Merry Christmas, We wish you a Merry Christmas, and a Happy New Year!

(Invite the audience to sing along.)

A Dancing Santa Puppet

Materials for Dancing Santas

- Patterns (pages 84–85)
- White tagboard (for the head)
- Lightweight red tagboard (red on both sides)
- Brass fasteners (5 per Santa)
- Beige construction paper
- Gold markers
- Cotton balls
- Large, sharp needles
- Scissors, black markers, glue, and tape

Teacher Preparation for Dancing Santas

1. Cut the red tagboard into 9″ × 12″ pieces. Cut the white tagboard into 6″ squares.
2. Duplicate one copy of the body and cap patterns for each child. Staple each pattern to a piece of red tagboard. Make sure you staple around the outside of the patterns.
3. Duplicate the head, face, and belt patterns on beige construction paper.
4. If you are working with young children, do steps 1 and 2 of the Student Directions for them.

Student Directions for Dancing Santas

1. Poke holes with a large needle on the body part patterns where indicated. Make sure the needle goes through both the pattern and the tagboard. Then cut out the body parts. Cut through both the pattern and the tagboard.
2. Cut out around the head pattern—leave extra paper around the head. Tape the pattern onto the white tagboard. Then cut it out. Make sure you cut through both the pattern and the tagboard.
3. Color the belt black and the buckle gold. Color the details on the face. Cut out both patterns.
4. Glue the face to the white tagboard head pattern as indicated on the pattern.
5. Cut out the cap pattern and glue it above the face.
6. Fasten the arms and legs *behind* the torso with brass fasteners. Be sure to slip the fasteners in from the front, opening the ends behind the Santa.
7. Fasten the head to the *front* of the torso with a brass fastener.
8. Glue the belt to the torso, over the brass leg fasteners.
9. Color the bottom part of the legs (the boots) and the bottom part of the arms (the mittens) black.
10. Pull cotton off the cotton balls. Glue small amounts onto the beard, eyebrows, and mustache. Also glue cotton to make cuffs on the pants and sleeves, to trim the edge of the jacket, to trim the bottom of the cap, and to make the pom-pom on the cap.

 Bashful?

 Happy?

 Exhilarated?

Dancing Santa Body Part Patterns

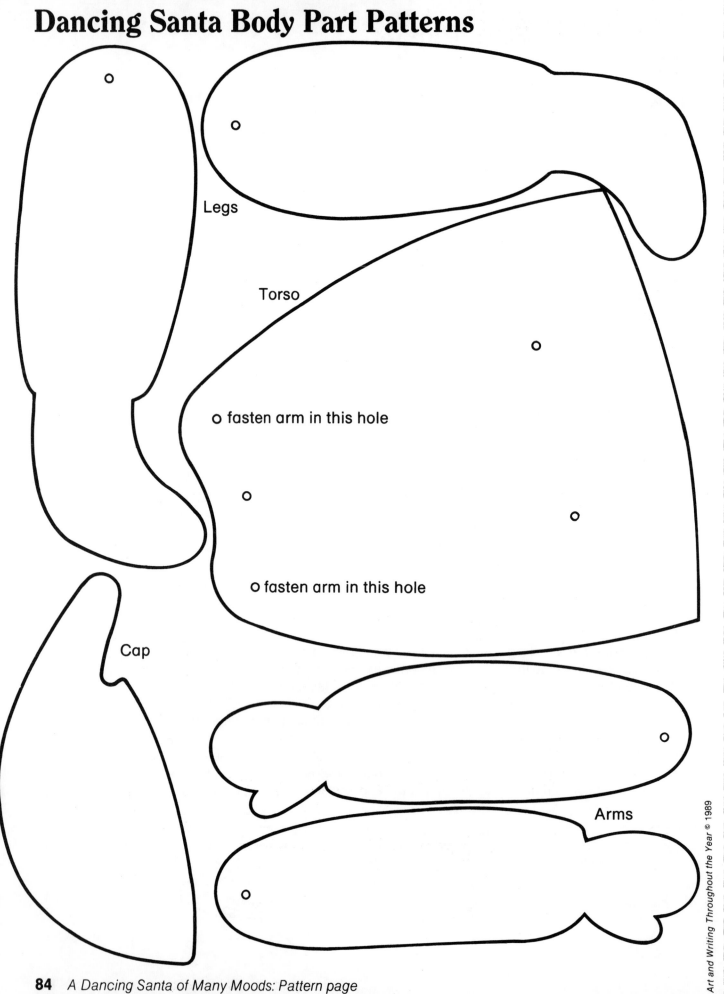

Legs

Torso

o fasten arm in this hole

o fasten arm in this hole

Cap

Arms

Art and Writing Throughout the Year © 1989

Dancing Santa Head and Belt Patterns

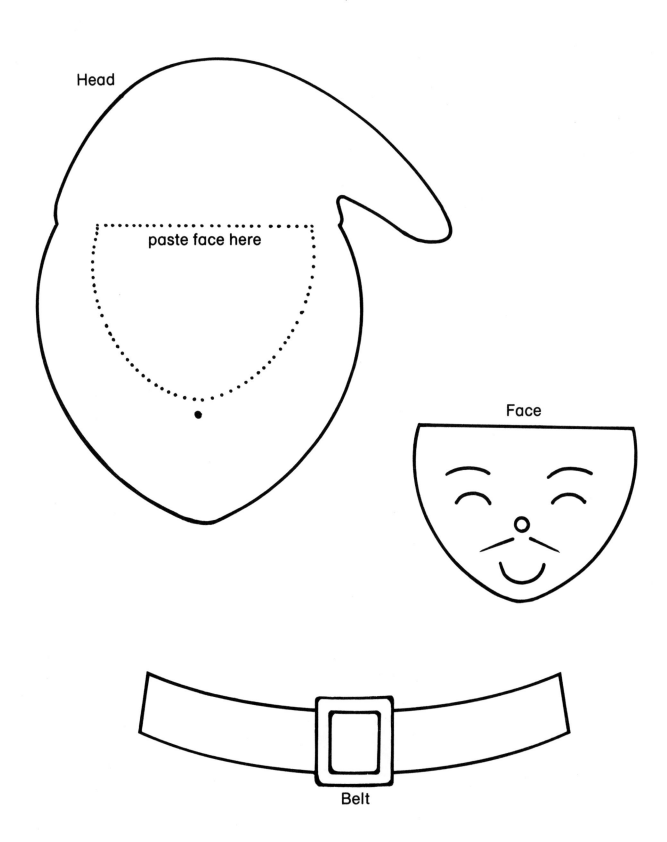

Head

paste face here

Face

Belt

Peace on Earth

Many words are said, written, and sung about world peace in the month of December. It is a good time to teach children about young people who have been leaders in the search for peace. For example, most children know about Samantha Smith, the American child who wrote to the Russian premier and was then invited to Russia to visit with him and to talk to Russian children. Samantha is now honored in both America and Russia for her efforts to bring the two countries closer together.

Using the Unit

Read the children the story of *Sadako and the Thousand Paper Cranes,* by Eleanor Coerr, before they begin to write. This moving story is about a young Japanese girl who is dying of cancer after World War II. As she lies in her hospital bed, she makes paper oragami cranes. Her goal is to reach a thousand cranes before she dies. Other Japanese children help her by making cranes and sending them to her.

Have the older children look in newspapers and news magazines for articles about people who are leaders in the search for peace. The *Christian Science Monitor* has many articles of this kind in December. Educational television stations often show films that can provide inspiration.

Duplicate and hand out the primary or middle-grade writing plans (pages 87 or 88-89). When the children have completed their writing projects, have them make the Doves in Wreaths (page 90). Display the wreaths and writing in the classroom.

A Peace Message

In *Sadako and the Thousand Paper Cranes,* peace meant a world without war. What does peace mean to you? Read the peaceful message below, then try writing two more messages. Remember that each line of your message should include your own thoughts on peace.

P People like to be listened to.
E Everyone I meet teaches me something.
A Art and music are languages all children speak.
C Children should help each other when they can.
E Each girl is my sister, each boy is my brother.

Message 1

P _____

E _____

A _____

C _____

E _____

Message 2

S _____

H _____

A _____

L _____

O _____

M _____

Art and Writing Throughout the Year © 1989

A Peaceful Planet

Throughout history, most people have wanted a lasting peace. Yet, the world has seldom been peaceful. What are your ideas for promoting peace in our world?

What do you think peace is? Describe three things you think are important for a peaceful existence.

1. _____

2. _____

3. _____

Think about the last time you saw a conflict between people. Without naming names, briefly describe what happened. Did anyone involved try to promote peace? Was it easy?

Name three places on the earth today where groups of people are in conflict. Briefly explain why they are not at peace with each other.

Art and Writing Throughout the Year © 1989

A Peaceful Planet *(continued)*

What efforts have world leaders made to try to assure lasting peace among all nations?

1. _____

2. _____

3. _____

4. _____

How do you try to promote peace?

Suppose you could magically create a world without war. What would the world be like? Do you think there would be total harmony among people? Why or why not?

Reread what you have written. Look for the best way to put your information together into an essay about peace. Refer to this plan only for specific facts when writing your essay.

Dove in Wreath

Materials for Dove in Wreath

- Patterns (page 92)
- Tagboard for dove: white, blue, or gold
- White tagboard for wreath
- Thick, white cord, such as macrame cord
- Medium-weight gold wire
- White thread
- White paint (for blue dove)
- Gold markers or green paint (for white dove)
- Sharp pencils, scissors, and tape
- Toothpicks
- Compasses
- Paper plates

Teacher Preparation for Dove in Wreath

1. Cut tagboard into 9″ squares. Make one square for each student.

2. Cut the white cord into 4′ lengths, making three pieces for each wreath. (An easy way to cut the cord is to wrap it around an object that has a 4′ circumference. Tape one end of the cord to the object, then wrap the cord around the object the appropriate number of times. Cut through all the cord in one place.)

3. Tie three pieces of cord together tightly at one end with gold wire or white thread. Make one set of cords for each student.

4. Duplicate the pattern page for the students.

Student Directions for Dove in Wreath

1. Cut the wreath out of white tagboard. Either cut out and tape the wreath pattern on the tagboard and cut out both together, or use a compass to draw the circles on the tagboard directly. (To do this, set the compass on the dot in the middle of the wreath. Place the compass pencil on the inner circle of the wreath. Use this setting to draw a circle on tagboard. Repeat for the outer circle. Then carefully cut out the wreath.)

2. Cut out the bird patterns. Trace around the patterns on blue, white, or gold tagboard. Cut out the wings and bodies. Lightly pencil fold lines on wings.

3. Make designs on the bird bodies and wings as follows:

For a blue dove: Pencil designs onto one side of each body piece. Make sure you make the same design on each piece. Also draw designs on the wings. Then spoon a tiny bit of white paint onto a paper plate. Dip the pointed end of a toothpick in the paint and dot over the lines of your design. Do not make solid lines. Let dry.

For a white dove: Repeat the steps for a blue dove using green paint or a gold marker instead of the white paint.

For a gold dove: Use a sharp pencil to "emboss" designs into the gold foil. Make sure you make the same design on both wings and both sides of the bird.

4. Tape gold wire on the unpainted side of one bird where indicated on the pattern.

5. Score the fold lines on the wings with a pair of scissors. Then fold the wings in half. Make sure the painted side of the wings face out.

6. Glue or tape the wings to the inside of the bird as indicated on the pattern. Tape or glue the two sides of the body together.

7. Braid the white cord fairly tight. Tape one end of the cord to the wreath. Attach the cord around the wreath by wrapping white thread around both. Space each wrap of the thread about a finger's width from the last wrap. Allow the extra length of cord to hang down.

8. Wrap gold wire around the hanging cord about 2″ from the end. Unbraid the end of the cord under the wire and fluff it out to form a tassel.

9. Attach the bird to the wreath by wrapping the gold wire attached to the bird around the top of the wreath three or four times. There should be about 3¼″ from the base of the bird's wings to the wreath. Make sure the bird is centered properly—it should seem to hover in the middle of the wreath. Bend the bird's wings out slightly.

10. Make a loop at the top of the extra wire so you can hang the wreath.

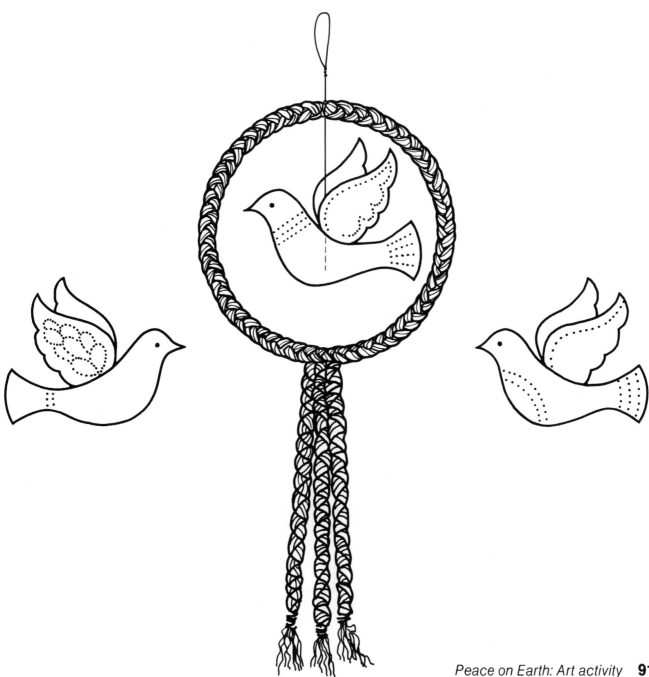

Dove in Wreath Patterns

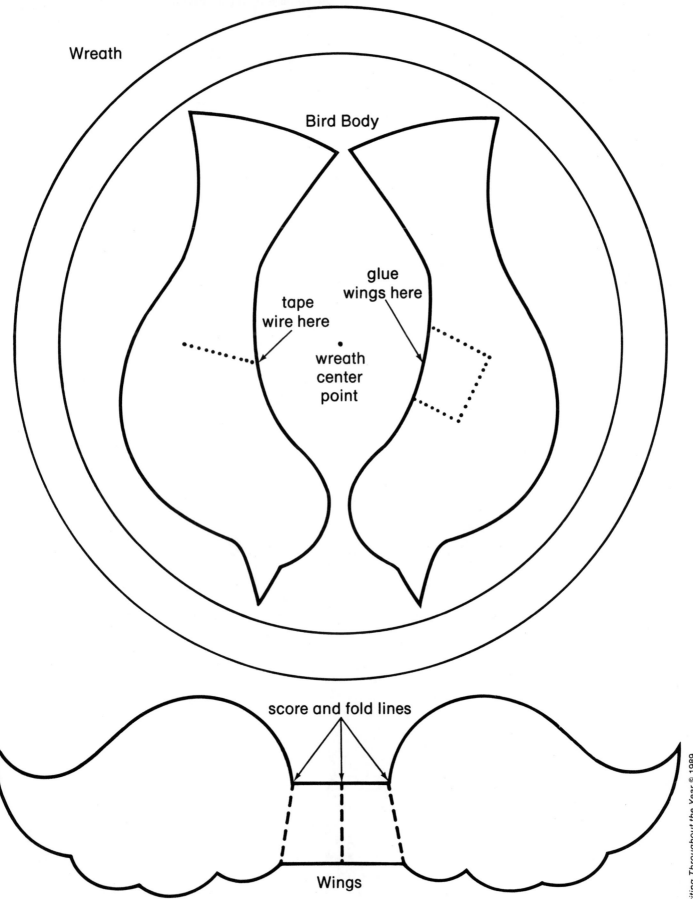

Wreath

Bird Body

glue
wings here

tape
wire here

•
wreath
center
point

score and fold lines

Wings

Art and Writing Throughout the Year © 1989

I Have A Dream

Celebrating Martin Luther King's birthday can liven up an otherwise dreary month. King's "I Have a Dream" speech makes an excellent starting point for a lesson on human rights, Black American history, and/or public speaking. The speech is readily available on tape, record, and video, and there are also posters of King which include all or part of the text.

Using the Unit

With younger children, start the unit by reading a biography of King aloud. Discuss the book, King's life, and the possible biases of the biographer. Then have the children select their own Black American biographies to read. (Note: It is important to preselect a large number of possible books at different reading levels or to provide the children with a list of these books.) Duplicate and hand out the Black American Biographies writing plan (page 94). Have the children use the plan to help them write a one-page book report about the biographies that they have read.

Discuss public speaking with the older children. Play the "I Have a Dream" speech for the class and ask them to evaluate the effectiveness of the speech. Before students write their own speeches, create a set of "Public Speaking Criteria." Ask the children to consider the following questions as they write and give their speeches:

- How much did I prepare for the speech?
- How much did I learn from writing this speech?
- How much did others learn from listening to my speech?
- Did I maintain eye contact?
- Did I speak too slowly or too quickly?
- Was my voice too soft?
- Did my visual aids contribute to my speech?

Duplicate and hand out the A Dream for the Future writing plan (pages 95-96). Have students write their own speeches using King's speech as a model. Set a time limit on the speeches of five to ten minutes.

Once children have finished their writing projects, have them make the Children of Many Nations art project (page 97). You could provide a collection of reference books that show the traditional clothes worn in different places. United Nations publications are good resources for this project.

Black American Biographies

A biography is a book about a real person's life. When you read a biography, you learn what makes that person special. Read a biography about a famous Black American. Then use this page to help you write about the book.

Book title: _____

Book author: _____

Who is the book about? _____

What is special about this person?

What was one of the most important events in this person's life?

What two new things did you learn about this person?

1. _____

2. _____

What traits and/or experiences do you and the famous person have in common?

Art and Writing Throughout the Year © 1989

A Dream for the Future

Dr. Martin Luther King, Jr. wanted social, political, and economic equality for blacks. He felt that one way to solve the problem of racial inequality was by "nonviolent resistance."

Think of the problems that we see in this country today. If you could pick only one, which problem would you most like to see solved? How would you try to solve it?

Briefly describe the problem you would like to solve.

Why do you think this problem exists?

How does this problem affect you? How does it affect other people?

Art and Writing Throughout the Year © 1989

A Dream for the Future (continued)

List possible solutions to the problem. Make the solutions plausible—waving a magic wand won't work.

1. _____

2. _____

3. _____

Choose one of the solutions you listed. Explain what you need to do to get people to use your solution.

Reread what you have written. Look for the best way to put your information together into a speech about the problem and your solution. Think your speech out. Then write notes on one index card. Practice giving your speech quietly to a friend.

Children of Many Nations: A Cooperative Art Project

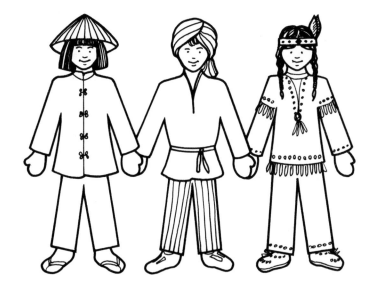

Materials for Figures

- Pattern (pages 98-99)
- Tagboard: beige and brown
- Construction paper in various colors
- Cloth scraps
- Tissue paper
- Glue, markers, scissors, and tape
- Traditional costume books
- Encyclopedias
- Yarn in various hair colors
- Scratch paper

Teacher Preparation for Figures

1. Duplicate one set of figure patterns for each student.
2. Put out the materials on a central supply table.
3. Put up a numbered list so the children can record their country choices.

Student Directions for Figures

1. Choose a country. Write the name of the country on the class list. Do not pick a country that is already on the list.
2. Read about the traditional dress of the country. Try to find pictures to study.
3. Cut out the figure patterns and assemble the figure as indicated on the pattern. Trace around the pattern on a piece of tagboard and cut out the figure.
4. Cut out the face pattern and glue it to the figure. Color the details on the face.
5. Glue the hair to the outside of the face. Let dry, then style.
6. Choose the costume that your figure will wear. Draw a pattern for the costume on scratch paper. Just draw the outline—you don't need detail yet. Make sure your pattern fits the figure.
7. Use the pattern to cut out the costume from construction paper, cloth, or tissue paper.
8. Glue the costume pieces to the figure. Use markers and scraps to add details.

Materials for Display

- Large pieces of fadeless art paper
- Stapler, tape, and scissors
- Index cards

Teacher Directions for Display

1. Cut the fadeless paper to fit a wall display. Make sure you leave enough room for all the children's figures. Tape or staple the paper in place.
2. Tape the figures in place on the background paper. Make sure the hands of each figure touch the hands of its neighbors.
3. Have each child write his or her name and country neatly on an index card. Place the cards below the appropriate figures.

Children of Many Nations Figure Pattern

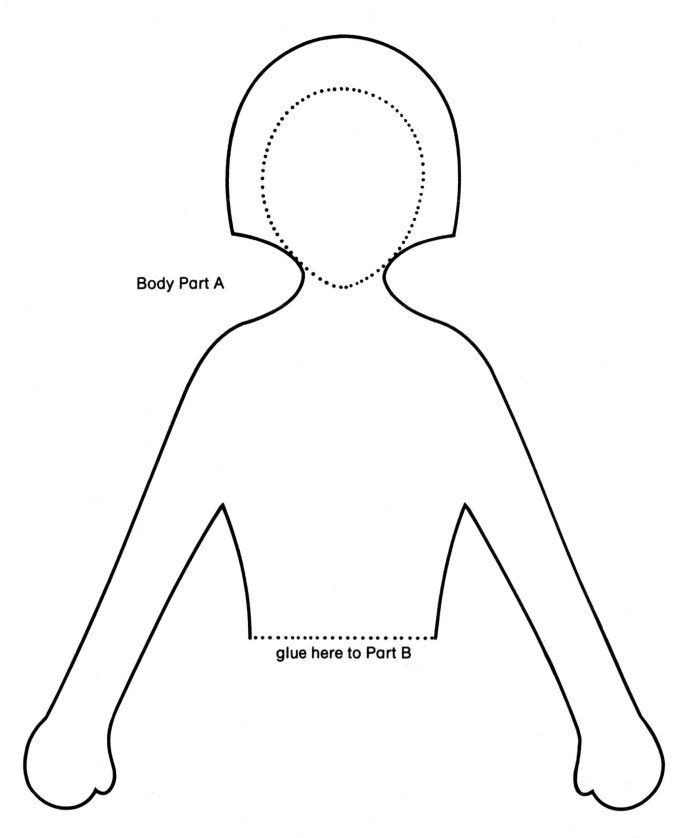

Body Part A

glue here to Part B

Art and Writing Throughout the Year © 1989

Children of Many Nations Figure Patterns

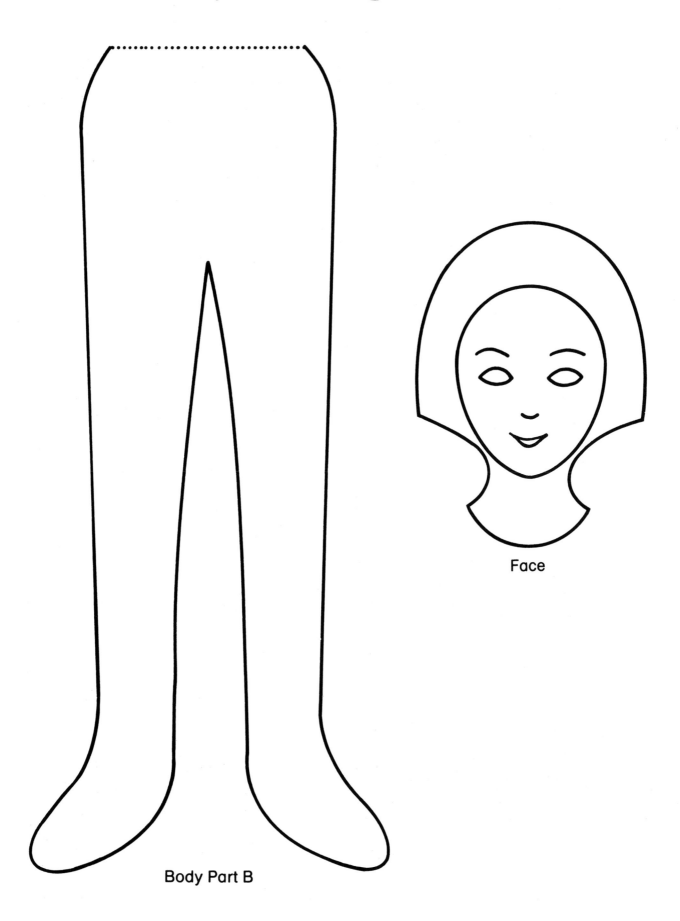

Body Part B

Face

Chinese New Year

Chinese-Americans have made tremendous contributions to the development of our nation. Yet, too often in American schools their contributions go unrecognized. The Chinese New Year holiday is a good time to introduce your students to Chinese-American history. You might want to try some of the following ideas, along with the writing and art projects, to create a week-long Chinese New Year celebration.

- Plant mung beans (the seeds are available in health food stores). Place the seeds on wet paper towels in a clear plastic shoe box. Check daily. (The beans are ready to harvest in four or five days.)
- Play Ping-Pong or organize a gymnastics competition.
- Use calligraphy pens to make ribbons with Chinese characters. Use the ribbons as prizes.
- Play China Trivia. Ask children to submit questions about Chinese culture. (They should use common reference books for their information.) Other children in the class have to find the answers to the questions.
- Have a Chinese feast. Use the mung beans and make Egg Foo Yong. (See page 201 for recipe.)

Using the Unit

Have children make the Chinese New Year Fans or the Long-Tailed Dragons (page 104 or 106) early in the week. Display the finished projects so children can enjoy them during the celebration.

Once the art projects are finished, read stories aloud to the children as a prewriting activity. Two insightful books to try are *China Homecoming* by Jean Fritz and *In the Year of the Boar and Jackie Robinson* by Bette Bao Lord. Then duplicate and hand out the primary or middle-grade writing plans (pages 101 or 102-103).

Have the younger children put their completed fortunes in cookies they make themselves or in little envelopes. (Li See or special New Year's red envelopes are available at a small cost in most Chinese shops at this time of year. These envelopes are traditionally used for money gifts. I like to place a penny in each one and give them to my students to use for their fortunes.)

If possible, tie in the middle-grade writing activities with a science unit on animal behavior.

Fortune Cookie Wishes

Your Uncle Max has just invited you to his fortune cookie shop. He wants you to write wishes to put in the cookies. Be careful what you wish for since wishes sometimes come true.

You will always _____

You will never _____

You will find money when _____

You will travel to _____

Your family will _____

A good friend will _____

The Year of the . . .

The Chinese calendar has a name for each year just as our calendar has a name for each month. Each year is named after an animal. The names of the animals repeat every twelve years.

Look at the calendar below. What is the name of the year you were born in? Do you think you are similar to or different from the animal sign for that year? Why?

Western Year	Animal Sign	Western Year	Animal Sign
1965, 1977	Serpent	1971, 1983	Boar
1966, 1978	Horse	1972, 1984	Rat
1967, 1979	Ram	1973, 1985	Ox
1968, 1980	Monkey	1974, 1986	Tiger
1969, 1981	Rooster	1975, 1987	Hare
1970, 1982	Dog	1976, 1988	Dragon

What year were you born? _____

What animal sign are you? _____

Write a complete description of your animal sign. Use words that help the reader picture this animal in his or her mind.

Art and Writing Throughout the Year © 1989

The Year of the . . . *(continued)*

List words or phrases that describe what you are like.

_____ _____

_____ _____

_____ _____

_____ _____

Think about the descriptions of your animal and of your personality. Then list three ways in which you and your animal are alike.

1. _____

2. _____

3. _____

List three ways in which you and your animal are different.

1. _____

2. _____

3. _____

Do you think you are basically similar to or different from your animal sign?

Reread what you have written. Look for the best way to put your information together into an essay about why you think you are similar to or different from your animal sign. Hand in your writing plan. Write your essay neatly.

Chinese New Year Fans

Materials for Fans

- 12″ × 18″ red construction paper
- Thick gold marker
- Black markers or black paint
- Paintbrushes, ruler, and stapler

Teacher Preparation for Fans

1. Use a ruler to make a straight gold line 1″ from the top of each piece of construction paper.

2. Once class starts, demonstrate how to make accordion folds. First fold a piece of paper in half widthwise, then again into fourths, then again into eighths, and then finally into sixteenths. Unfold the paper and smooth it out. Then, use the fold lines to make neat accordion pleats.

Student Directions for Fans

1. Accordion-pleat your paper. Then unfold it and smooth it out.

2. Pick one of the designs that follows. Use black paint to make the designs on your fan.

3. Let the fan dry.

4. Accordion-pleat the fan.

5. Staple the pleats together at the bottom. Staple twice—once from each side.

Fan Design A

1. To make the first row, dip a paintbrush in paint. Then lay the brush along the fold lines to make the vertical petals, and perpendicular to the fold lines to make the horizontal petals. Repeat for each flower, working from left to right.

2. To make the second row, lay the brush diagonal to the fold lines.

Fan Design B

1. To make the first row, repeat step 1 for Fan Design A. Then add diagonal brush marks between each of the four petals on each flower.

2. To make the second row, lay the brush once along each fold line.

Fan Design C

1. Start on fold line #8. Dip a paintbrush in paint, and then lay the brush along the fold line to make the vertical petals. Repeat perpendicular to the fold line to make the horizontal petals. Add diagonal brush marks between each of the four petals.

2. Add a second set of petals outside the first flower. Then add diagonal brush marks between each set of petals.

3. Starting from the outer edge, make two diagonal marks along each fold line.

Long-Tailed Dragon

Materials for Dragons

- Patterns (page 107)
- 12″ × 18″ red construction paper
- Gold paper
- Crepe paper: purple, blue, or yellow
- Popped popcorn (two per dragon)
- Scissors
- Stapler
- Glue

Teacher Preparation for Dragons

1. For each dragon, cut four 2″ × 18″ strips of red construction paper. Staple two strips together so you have one 2″ × 35″ strip of paper. Repeat with the other two strips. Then staple the first strip to the second strip at a right angle as shown.

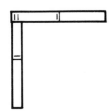

2. Duplicate the dragon patterns on red construction paper. Make one set for each child.

3. Cut 6″ crepe-paper strips for tail.

Student Directions for Dragons

1. Fold the long strips of red construction paper as shown. Continue until the paper is completely folded.

2. Color the eye patterns and then color the scales a dark color. Then cut out the dragon head and eyes.

3. Fold the dragon head along the fold lines. Staple the head to the folded strips of paper at one end.

4. Glue one piece of popcorn to each eye. Glue the eyes in place on the dragon head.

5. Cut out the tongue. Trace around the tongue onto a piece of gold paper. Cut out the gold tongue and glue it inside the lower jaw.

6. Staple several crepe-paper strips to the other end of the body for a tail.

Long-Tailed Dragon Patterns

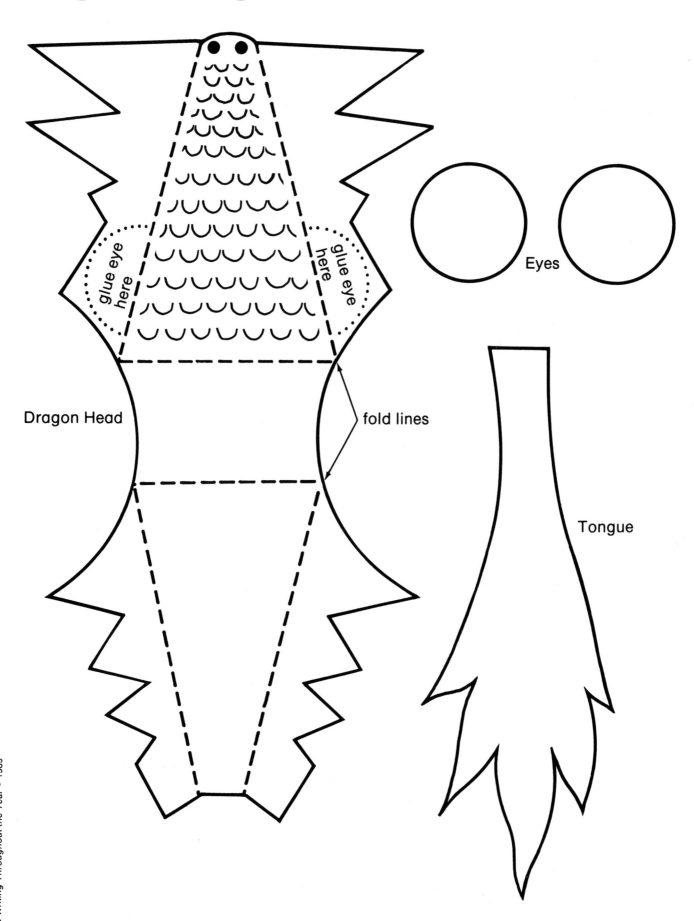

glue eye here

glue eye here

Dragon Head

fold lines

Eyes

Tongue

Mardi Gras Masks

Masks fascinate the child in all of us, and it seems a shame to confine them to Halloween and October. Mardi Gras gives us another holiday to celebrate with masks. The Mardi Gras masks in this unit are African-inspired, but they can be used in various ways. If you wish to capitalize on the African designs to do a unit on African art, be sure to borrow the set of slides on African art provided by the National Gallery of Art Loan Program. (These slides are available for free use—just write to the National Gallery in Washington, D.C.) You will need to edit the show; however, a half-hour viewing will give children a basic feel for the elements of style in early African art.

Using the Unit

Plan to have the class work on the Mardi Gras Masks (page 113) for several days. On the first day I usually set up a painting table and have small groups of children paint throughout the morning. Then, on the next day, I have the whole class start on the arrangement of design features and threading the hair. Make several models yourself before setting up the project for the children so you will appreciate the complexity of the project. While younger children have successfully completed the Mardi Gras masks, you might want to have them do the Alternate Masks (page 118) instead. These masks are less complex and require less teacher preparation time.

Both the primary and middle-grade writing plans (pages 109 or 110–111) are fairly simple. Have both groups use the writing plans as prewriting activities. They should write drafts of their stories on separate pieces of paper. You might display the finished writing with the masks. Make sure that younger children understand that they should write from the point of view of the person behind the mask—not about themselves. Emphasize to middle-grade students that writing plans are story starters, nothing more. Since this plan is quite detailed, they may wish to answer only some of the questions.

A Mask for Mardi Gras

When people wear masks, you cannot tell what they are like. Imagine someone taking the mask that you made and hiding behind it. What is this masked person really like? Tell the story in the first person (use "I").

What is your name? (Remember, you are now the person behind the mask.)

What do you look like without your mask? Be descriptive.

How old are you?

What type of costume are you wearing for Mardi Gras?

What do you like to do for work and for play?

What type of mood are you in? Are you feeling friendly, mean, lonely, kind, sad, worried, or happy today? Why?

Art and Writing Throughout the Year © 1989

The Mardi Gras Mask

You are a magical mask maker. You have a store in New Orleans. When someone puts on one of your masks he or she becomes a completely different person.

One day a child bought one of your masks to wear during Mardi Gras.

(story title)

Describe your store. _____

Describe the child. _____

What kind of mask did the child buy? Tell what the mask looked like.

Tell what the boy was like before he put on the mask.

Tell what the boy was like after he put on the mask.

Art and Writing Throughout the Year © 1989

The Mardi Gras Mask (continued)

What happened when the child discovered that the mask was magical?

Did the child get into trouble wearing the mask?

What made the child decide to take the mask off?

Art and Writing Throughout the Year © 1989

The Mardi Gras Mask *(continued)*

How did the child's family find out about the mask's powers?

Describe the conversation you had with the child's parents
when they came to your shop to talk about the mask.

What happened to the mask? Did the child decide to get rid of the mask?

Reread what you have written. Think about the best way to
put your ideas together into a story. Hand in your writing
plan. Write your story.

Mardi Gras Masks

Materials for Masks

- Patterns (pages 116-117)
- Design Practice Page (page 115)
- Stiff oval paper plates
- Tempera paints: black, blue, and purple
- Red-orange spray paint
- Small salad macaroni
- Rubbing alcohol
- Food coloring
- Raffia in various colors
- Colored toothpicks
- Tiny white beans, red lentils, and split peas
- Tagboard
- Styrofoam meat trays
- White glue, scissors, hole punch, knife, and paintbrushes

Teacher Preparation for Masks

1. Duplicate one copy of the mask pattern. Use the pattern to draw the eyes, nose, and mouth lines on each plate so the children can position the features.

2. Punch holes in each plate for hair as shown in the samples.

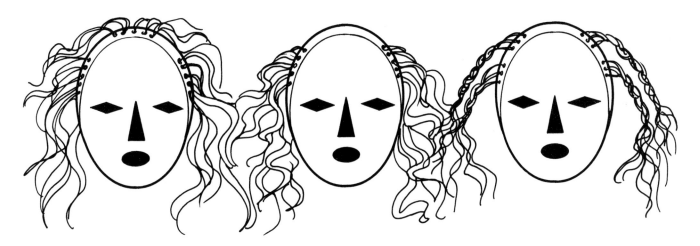

3. Duplicate one copy of the nose, mouth, and eye patterns. Cut out the patterns. Trace around the nose pattern on pieces of tagboard. Use sharp scissors or a knife to score the fold lines for the children. Cut the eyes and mouths out of Styrofoam meat trays. To cut the eyes quickly, slice off the edges of a meat tray. Then use a knife to slice the tray lengthwise into 1¾" strips. Make diagonal cuts to form the diamonds.

4. Spray paint the mouths red-orange. (Tempera does not stick to Styrofoam.)

5. Color the macaroni. Shake a small amount of the macaroni in a jar with food coloring and a little rubbing alcohol for quick drying. Start with one batch each of blue, yellow, and red. Then mix the yellow and blue together to get green. Spread the macaroni out on newspaper to dry each time you color.

6. Prepare the tempera. Add a little black to each color to make somber hues.

7. Duplicate the Design Practice Page for the children.

Student Directions for Masks

1. Cut out the nose pattern. Fold along the scored lines and overlap sections 1 and 2 to form a tentlike shape. Glue the parts together. Glue the nose on the mask.

2. Paint the mask one color. Leave the mouth and eye areas blank. Paint your nose-piece the same color. Allow to dry.

3. Practice designs for the mask on the Design Practice Page. (Note to teachers: you should show children sample designs at this point. Caution the students to make specific patterns with the materials—scattered or widely spaced beans can look like chicken pox!)

4. Glue the eyes and mouth in place on the plate. Then glue the beans, macaroni, and toothpicks in place. Let dry.

5. Thread the raffia through the hair holes. Braid if desired.

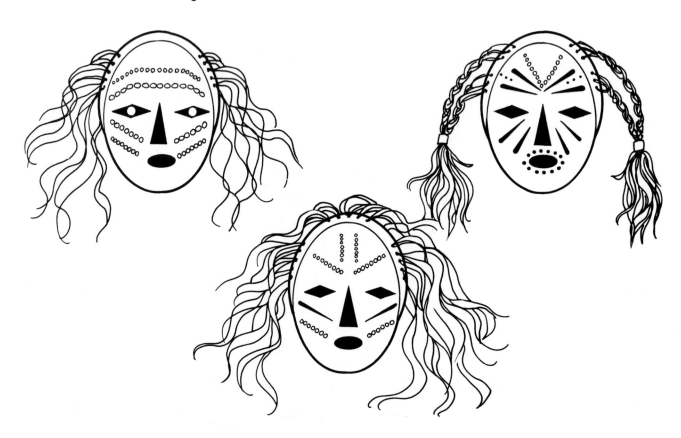

Design Practice Page

Mardi Gras Mask Pattern

Art and Writing Throughout the Year © 1989

Mardi Gras Mask Patterns

Eyes (cut 2)

Nose

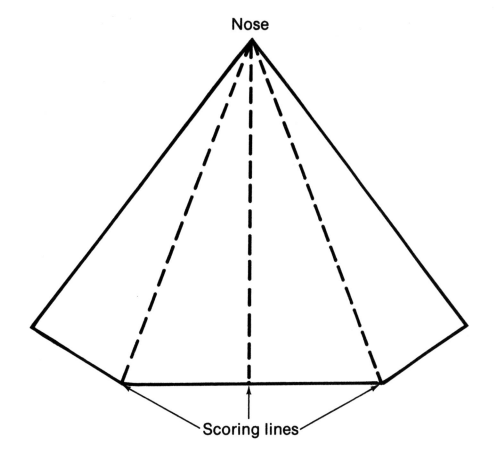

Scoring lines

Mouth

Alternate Masks

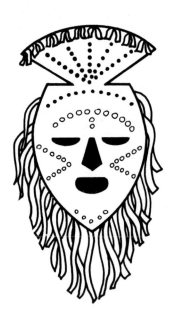

Materials for Alternate Masks

- Patterns (pages 121-122)
- Design Practice Page (page 120)
- Tagboard: white if the mask is to be painted, or colored tagboard: orange, purple, and blue
- Paint: white, orange, purple, and dark blue
- Crepe paper: yellow, orange, and purple
- Cotton swabs
- Scissors, stapler, and paintbrushes
- Paper plates
- Plastic spoons

Teacher Preparation for Alternate Masks

1. Duplicate one copy of the mask pattern. Join the two parts as indicated on the pattern. Cut along the solid lines of the mouth, eyes, and nose. Use the completed pattern as a template. Place on tagboard and trace around the outside of the mask and the cut lines of the features. Make one mask for each student. (If you wish, have older students do this step for themselves.)
2. Cut along the mouth, nose, and eye lines with small sharp scissors. Do not cut the indicated fold lines. (To make cutting easy, pierce the corners of each feature with a large needle. This will provide holes in which to insert the scissors.)
3. Cut the crepe paper into ½" × 9" strands for the long hair and ½" × 4" strands for the short hair. (See page 30 for quick cutting tips.)
4. Cut 2" × 4" strips of tagboard. Make one strip for each child.

Student Directions for Alternate Masks

1. Cut out the mask. Fold the eyes, nose, and mouth flaps up.
2. If you are using white tagboard, paint the mask a solid color. Let it dry.
3. After the mask is dry, turn it over and glue on the crepe paper strips for hair. First fold the short strips in half and glue them to the top of the mask, close to the edge of the curve. Then glue the long strips, one next to another, along the side of the face (except along the tabs.) Glue the strips straight out—they will hang better once the glue has dried. If your mask is orange, use purple crepe; if your mask is purple, use orange or yellow crepe; if your mask is blue, use yellow or orange crepe.

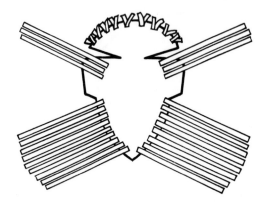

4. Practice designs for the mask on the Design Practice Page. (Note to teachers: You should show children sample designs at this point. Caution the students to make specific designs.)

5. Pencil your final design lines onto the front of the mask. Then spoon paint onto a plate. Paint dots along the lines using a cotton swab. Use purple and white on an orange mask; and orange and white on blue or purple masks. Let dry.

6. Staple each side of a 2″ × 4″ tagboard strip to the tags on the mask. This will cause the whole mask to bend slightly. Use this back band to hang your mask on a wall or bulletin board.

Design Practice Page

Art and Writing Throughout the Year © 1989

Alternate Mask Pattern

Mask Part A

tab

tab

join here to Part B

Alternate Mask Pattern

Mask Part B

fold up

fold up

fold up

fold up

Art and Writing Throughout the Year © 1989

Valentine's Day

February is a great month for celebrating. I particularly love Valentine's Day— covering hearts with tissue paper squares dipped in glue is very satisfying, as is cutting out hearts from dough or twisting ribbon around wire heart shapes.

In my classroom, students are given large white paper hearts. They write their own names decoratively in the center and then pass these hearts to the children sitting next to them. Each child writes a positive message about the person whose name is in the center of the heart. I sit in the middle of the room, writing notes to each of my students in turn. The hearts are passed around until every student has had the chance to write on each heart. Good feelings proliferate, and the finished hearts are tangible evidence of positive esteem.

Using the Unit

The primary writing plan (page 124) will help children understand the use of similes and metaphors. I usually read passages from E. B. White's *Charlotte's Web* or Natalie Babbit's *Tuck Everlasting* to help children appreciate the effective use of similes and metaphors. Use the writing plan as a starter, then have children write Valentine descriptions for each other.

The Historical Valentines writing plan for middle-grade students (pages 125-126) fits well into a lesson on letter writing. Before the children begin to write, help them come up with a class list of famous couples. (The three couples on the plan are just examples.)

The Special Valentines (page 127) are simple for both the teacher and the students. The project should not take more than one period to complete. Have the children take home their completed valentines to give to someone special.

Your Love Is Like . . .

Words that are put together in a certain way can help you form pictures in your mind. Similes and metaphors help you create these pictures and they make writing interesting. The following is one famous simile.

My love is like a red, red rose
that's newly sprung in June.

Write descriptions of someone special for Valentine's Day. Use the lines below to help you create your own similes.

Your smile is like _____

Your eyes are as _____

Your hands are like _____

You are as kind as _____

Your love is like _____

You are _____

Art and Writing Throughout the Year © 1989

Historical Valentines

John and Abigail Adams were a famous early American couple. They were a husband and wife who were often separated by their work. However, they stayed very much in love and their letters to each other were filled with sentiment.

Pick a famous couple in history to write about. Franklin and Eleanor Roosevelt, Martin Luther and Coretta King, and Pierre and Marie Curie are examples. Do some research on the couple you have chosen. Then use these pages to help you write two romantic letters. Pretend to be the husband writing to the wife in one, and the wife writing to the husband in the other.

Which couple have you chosen? _____

List some descriptive words that tell about each of these people.

_____ _____

_____ _____

_____ _____

Read about this couple's history as a couple. How or when did they meet? For how long were they together? Were they famous before or after they met? Did they have any children?

Historical Valentines *(continued)*

Describe what these people did. Did they work together or separately? What caused them to spend time apart? For example, did their work involve a great deal of travel or other times apart?

List your sources of information.

1. _____

2. _____

3. _____

4. _____

Reread what you have written. Think about the best way to use this information in your two Valentine's Day letters. Remember that the details that you've learned about this couple, if used carefully, will make your writing come alive. Write the letters on stationery, using the proper letter format. Address the envelopes for your letters as authentically as you can. Illustrate with hearts and flowers for Valentine's Day.

Art and Writing Throughout the Year © 1989

Special Valentines

Materials for Camellia Valentines

- Heart card pattern (page 129)
- Camellia pattern (page 130)
- Construction paper: pink and green
- Tissue paper: white, pink, magenta, and lavender
- Scissors, paste, and stapler

Teacher Preparation for Camellia Valentines

1. Layer eight pieces of tissue paper together, alternating colors as you go. Place the tissue paper layers on top of a piece of pink construction paper.

2. Duplicate one copy of the camellia pattern to use as a template. Cut it out.

3. Trace around the flower pattern onto the top sheet of tissue paper. Make one flower for each child. (If you make the patterns in rows, they are easy to cut apart.) Staple the tissue paper and construction paper together in the center of each flower pattern. Cut the patterns apart.

4. Duplicate the leaf pattern on green construction paper. Make one copy for each child.

5. Duplicate the heart card pattern on pink construction paper. Make one copy for each child.

Student Directions for Camellia Valentines

1. Fold the heart pattern along the fold line. Cut out the top "v" of the heart. Then unfold the pattern and cut out.

2. Cut out the leaf pattern.

3. Carefully cut out your tissue-paper flower. Make sure you cut through all the layers of tissue and construction paper.

4. Glue the tissue-paper flower in the center of the leaves.

5. Lift and pinch each layer of tissue near the staple to create the petals. Do one layer at a time, starting with the top layer.

6. Refold the heart in half and paste the flower on the font of the card.

Materials for Flower-Wreath Valentines

- Heart pattern (page 129)
- Small heart pattern (page 130)
- Construction paper: pink and white
- Tissue paper: white and red
- Scissors and paste

Teacher Preparation for Flower-Wreath Valentines

1. Cut the tissue paper into 1½" squares. (To do this quickly, fold large sheets in half, slice with a knife, then fold in half again, and slice again. Repeat two more times, then cut the layers into 1½" strips on a paper cutter. Cut into squares with scissors.)
2. Duplicate the heart card pattern on pink construction paper and the small heart patterns on white construction paper. Make one heart card and one white heart for each child.

Student Directions for Flower-Wreath Valentines

1. Fold the heart pattern along the fold line. Cut out the top "v" of the heart. Then unfold the pattern and cut out.
2. Make tissue-paper flowers out of red and white tissue as shown:

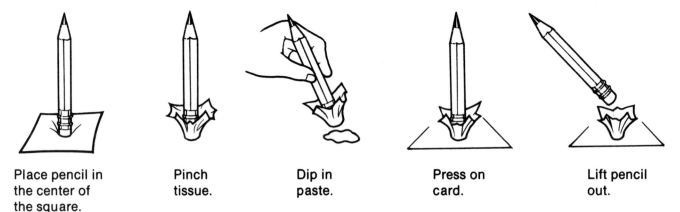

Place pencil in the center of the square.

Pinch tissue.

Dip in paste.

Press on card.

Lift pencil out.

Paste the flowers in an alternating red-white pattern on the dots marked on the heart pattern.
3. Cut out the small white heart and paste it in the center of the large heart.
4. Refold the card when dry.

Heart Card Pattern

fold line

Camellia and Small Heart Patterns

Camellia Flower

Camellia Leaf

Small Hearts

Spring Poetry

March signals the beginning of spring, and most children are such hopeful people that every sign of spring is a cause for jubilation. This is an excellent time for colorful birds to fly across bulletin boards and construction-paper butterflies to hover midair over closet doors. March is also a wonderful time to focus on poetry with children, since spring is a subject that is dear to the heart of every poet or poet-to-be. Non-rhyming poetry, within an established structural framework, is the easiest type of poetry for young writers. The writing plans in this unit focus on this form.

Using the Unit

For younger children, read examples of haiku poems as a prewriting activity. Explain how to count the syllables in each line, and point out that a single line does not have to be a complete sentence. Then duplicate and hand out the writing plan (page 132). Have the children complete these three poems started on the page.

With older children, you should discuss word poems. In these poems, a line of poetry is written for each letter in a particular word. Duplicate and hand out the writing plan (page 133). Ask children to think of all the ways they can think of to say spring in other languages. You may want them to research the subject. Then have the children write a word poem using one of the "spring" words. (Six possible words are already included on the writing plan.) Once children have completed their writing, they should copy their poem over on a clean piece of paper. (You should point out that the best poets make many revisions in their poems before they are published.)

Once students have finished their poems, have them make the birds and/or butterflies (pages 134 or 136). Some children like to use encyclopedias and nature books when they design the markings on their birds and butterflies, while others prefer fantastic designs pulled from their imaginations. Allow the children to do both! If you have the time, let each child do several birds or butterflies.

Besides displaying the finished projects in the classroom, you might want to use them to make thank-you or get-well cards. To do this, have the children fold colored construction paper in half. Then glue the bird or butterfly to the outside of the card.

Birds and Butterflies: Spring Haiku

Haiku are three-line Japanese poems. They have seventeen syllables: five syllables in the first line, seven syllables in the second line, and five syllables in the third line. Haiku poems often describe things in nature. Here is a sample:

> Third graders writing
> Poems of colorful birds
> Moving in the wind.

Use the lines below to help you write your own haiku poems about spring. Pick the best poem and copy it over on another piece of paper.

(5) Sweet-sounding bird songs

(7) Hover in the morning air

(5) _____

(5) The warm spring sunshine

(7) _____

(5) _____

(5) Monarch butterfly,

(7) _____

(5) _____

Art and Writing Throughout the Year © 1989

Le Printemps: A Spring Poem

Poems use descriptive words that help you use your senses to understand the message. These words appeal to your senses of sight, touch, smell, hearing, and taste. For example, the following stanza appeals to four senses:

> Sweet rose scent fills the air
> as slow, cool shadows slide
> silently across the silky green grass.

Use descriptive words to write a poem about spring. Pick one of the words that means spring from the list at the right. Start each line of the poem with a letter from the word. For example, if you pick the word "vensa," the first line would start with a "v," the second line would start with an "e," and so on.

vensa (Russian)
vernum tempus (Latin)
rabieh (Arabic)
le printemps (French)
primavera (Italian)
der Fruhling (German)

(title)

Spring Birds

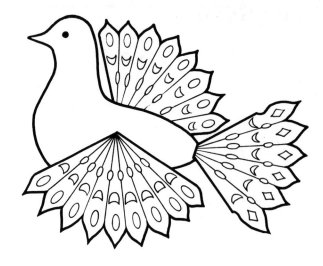

Materials for Birds

- Pattern (page 135)
- White tagboard
- White onionskin paper
- Paints or markers
- Paintbrushes (if using paints)
- Scissors, tape, and stapler

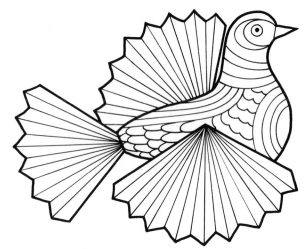

Teacher Preparation for Birds

1. Duplicate one copy of the pattern to use as a template. Cut out and trace around the pattern onto pieces of tagboard. Make one bird body for each student.
2. Cut wing slits in the tagboard patterns as indicated on the pattern.
3. Cut out the bird patterns for younger children.

Student Directions for Birds

1. Cut out the bird pattern.
2. Make designs on both sides of the bird using paints or markers. These designs can be fanciful or realistic.
3. Accordion-pleat an 8½″ × 11″ piece of onionskin paper to use as wings. (Note to teacher: See page 104 for folding guidelines.) If you wish, cut shapes along the fold lines, as in making a snowflake.
4. Or, unfold the wing paper and draw a simple border design on both ends of the wings. Then refold the wings.
5. Slip the wings halfway through the slit in the bird. Open them up on both sides.
6. For the tail, accordion-pleat another piece of onionskin paper. Cut it in half. Decorate to match your wings. Then slip one of the folds over the tail end of the bird. Staple in place. Fluff out the tail.

Spring Bird Pattern

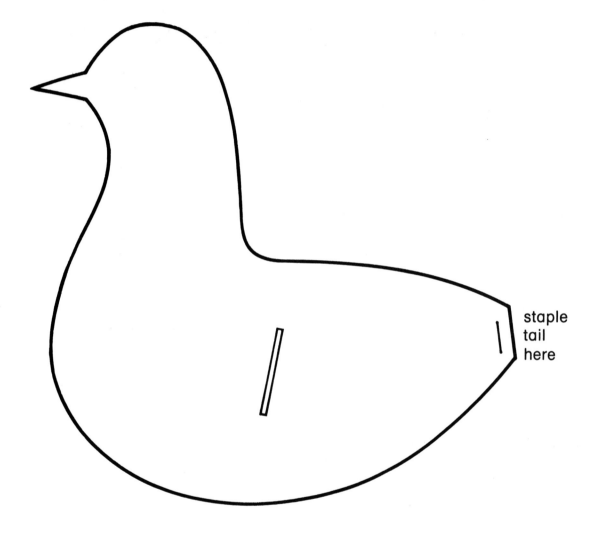

staple
tail
here

Art and Writing Throughout the Year © 1989

Butterflies with Shadow Wings

Materials for Butterflies

- Pattern (page 137)
- Construction paper: lavender and purple, light green and dark green, or black and yellow
- Pipe cleaners: purple, green, or black
- Scissors, markers, and glue

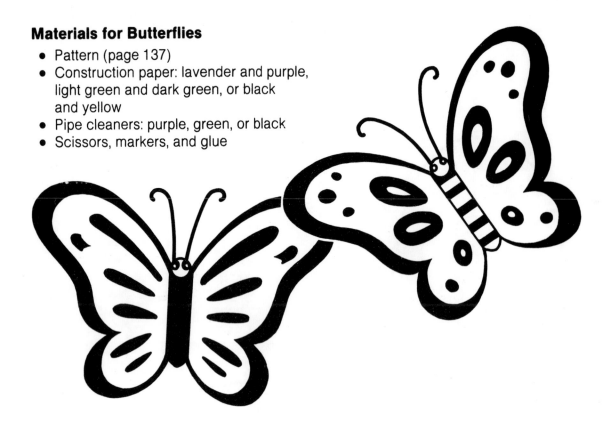

Teacher Preparation for Butterflies

1. Duplicate the patterns for the students to use as templates. Make one set of patterns for each child.
2. Cut the pipe cleaners in half.

Student Directions for Butterflies

1. Cut the pattern page in half. Staple the butterfly to light construction paper (lavender, light green, or yellow) and the shadow pattern to the corresponding dark construction paper (purple, dark green, or black). Make sure you staple outside the patterns.
2. Cut out the butterfly pattern and the shadow pattern.
3. Use a pencil to sketch designs on the butterfly's wings. Make sure your designs are symmetrical. Then color in the designs with markers.
4. Choose the corresponding pipe-cleaner color. Then fold the pipe cleaner in half. Bend each end down slightly to make a little ball on each end. Then bend each side of the cleaner around a small tube, such as a glue stick, to curve the antennae.
5. Glue the base of the antennae (the "v") to the head of the shadow. Then glue the top of the butterfly over both the shadow and the antennae. Make sure you only glue the center of the butterfly—not the wings. Hold until dry. Then gently fold up the butterfly's wings.

Butterfly and Shadow Patterns

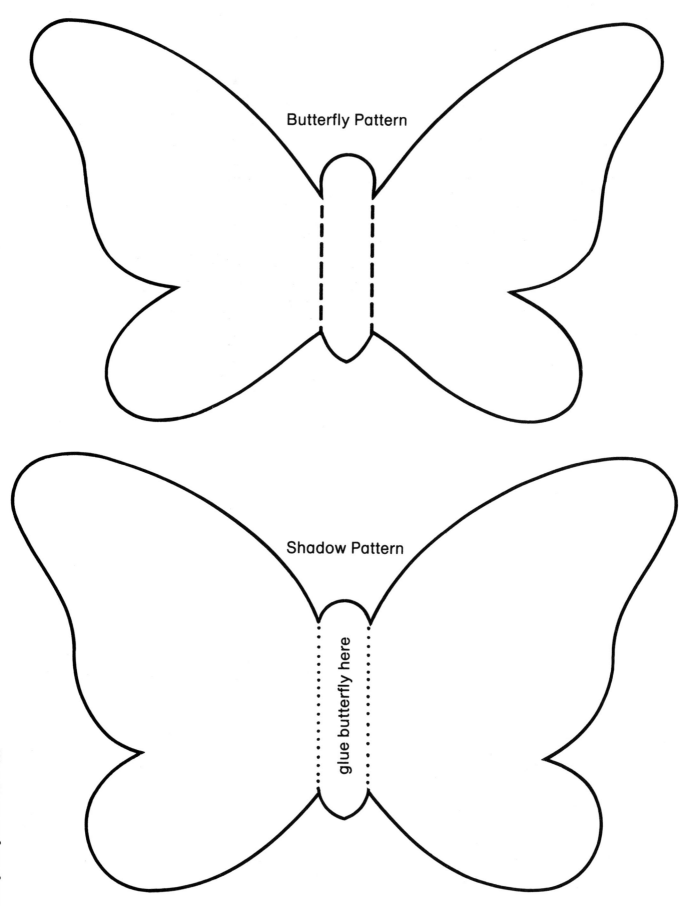

Butterfly Pattern

Shadow Pattern

glue butterfly here

Rabbits and Eggs

Do rabbits really lay eggs? Many children think they do! Our celebration of Easter has lead to an indelible association between the two in the minds of children. In this unit, students get to make delightful Bunny Baskets to fill with Rubber-Cement Resist Eggs. (These eggs have a delicate silk-screenlike pattern—they're almost too pretty to eat!) The week my students make their eggs, we also make egg salad. For some children, this will be the first time they have tried this unique taste sensation.

Using the Unit

For younger children, duplicate and hand out the Great Easter-Egg Hunt writing plan (page 139). Explain that the children do not have to use all the phrases listed on the page. If you wish, you can draw eggs on the board and ask the students to contribute other story starters. Or, you could pass out blank paper eggs and have the children write words or phrases to make a class set of story starters. (If you do this, be sure to save the eggs to help next year's students. I have a whole file of ideas which I've carried over from one class to the next, and I find that my students love to read the work of previous classes.) Have the children write their final stories in an egg-shaped book made of construction paper.

Use the An Easter Bunny? writing plan (pages 140–141) with older children. Before the children begin to write, point out that cute Easter animals grow up and have to be cared for long after Easter. If you can, have a speaker from the local S.P.C.A. come to the classroom to talk to the children. (These speakers will usually come free of charge and often bring several live animals with them.) The story plan here is based on a pet rabbit. If you wish, you can have children write about another Easter pet instead.

Have the children make the Rubber-Cement Resist Eggs (page 142) and the Bunny Baskets (page 143) before Easter. I ask my students to bring in their own hard-boiled eggs in empty egg cartons. However, I also boil an extra dozen at home, since kids often break their own despite their best efforts. For reasons of time, I limit the children to one or two eggs each.

The Great Easter-Egg Hunt

It is the morning of a beautiful Easter Sunday. The annual great Easter-egg hunt is in progress. Read the phrases in the Easter eggs below. Then use at least one of the phrases in a story about the Easter-egg hunt. Write on the back of this page if you need more room.

(story title)

An Easter Bunny?

People often give rabbits as pets for Easter. What are some of the advantages and disadvantages of owning a rabbit? Do you think that you would want a rabbit for a pet?

List descriptive words or phrases that explain how a rabbit's behaviors and habits could delight you.

_____ _____

_____ _____

_____ _____

List descriptive words or phrases that explain how a rabbit's behaviors and habits could frustrate you.

_____ _____

_____ _____

_____ _____

Describe what it would be like to live with a rabbit. Where would you keep it? Would there be problems with feeding it? What responsibilities would you have? Do you think someone else in your family would help you care for your pet?

Art and Writing Throughout the Year © 1989

An Easter Bunny? *(continued)*

List three reasons why a rabbit could be a useful pet.

1. _____

2. _____

3. _____

How would you and a rabbit spend time together?

Explain why you think a rabbit could be happy or unhappy as a child's pet.

Reread what you have written. Then use the information to write an essay on why you would or would not like to own a rabbit. Be sure to support your opinion with examples.

Rubber-Cement Resist Eggs

Materials for Rubber-Cement Resist Eggs

- Hard-boiled eggs (1–2 per child)
- Vinegar
- Food coloring
- Hot water
- Rubber cement
- Bowls for color baths
- Paper towels
- Empty egg cartons
- Spoons

Teacher Preparation for Rubber-Cement Resist Eggs

1. Prepare the color baths for the eggs. Add one tablespoon of vinegar and a few drops of food coloring to about one cup of hot water.

2. Put out the empty egg cartons for children to keep their eggs in.

Student Directions for Rubber-Cement Resist Eggs

1. Drip—do not paint—rubber cement in delicate drizzles all over your egg. Hold the egg carefully between your thumb and index finger and blow it dry.

2. Use a spoon to carefully dip the egg into a color bath. Blow the egg dry.

3. Once the egg is dry, carefully rub off the rubber cement with your fingers.

4. If you wish, repeat steps 1–3 using another color.

5. Place the egg in an empty egg carton until you are ready to take it home.

Bunny Baskets

Materials for Bunny Baskets

- Patterns (pages 144–145)
- Pastel or light brown construction paper
- Brass fasteners (one per basket)
- Cotton balls
- Markers, scissors, paste or glue, hole punch, and stapler
- Easter grass

Teacher Preparation for Bunny Baskets

1. Duplicate one set of patterns on pastel or light brown construction paper for each child.

Student Directions for Bunny Baskets

1. Cut out all the patterns.
2. Color the whiskers black on both sides. Color in the ears, eyes, and mouth.
3. Punch holes in the head pattern where indicated.
4. Thread each "petal" of the head onto the brass fastener. The ends of the fastener should be pointed toward the back of the bunny's head. Open the ends and press them flat inside the head. The head should look like this:

5. Write your name on the name line of the body. Then fold the body as indicated on the pattern. Paste the ends together.
6. Staple the head to the front end of the body. (Note to teachers: You may have to help with this.) Make sure the fastener faces out from the body.
7. Glue on the legs, whiskers, and eyes.
8. Glue on a cotton ball for a tail, and a small piece of cotton over the fastener for a nose.
9. Fill the basket with Easter grass.

Bunny Basket Patterns

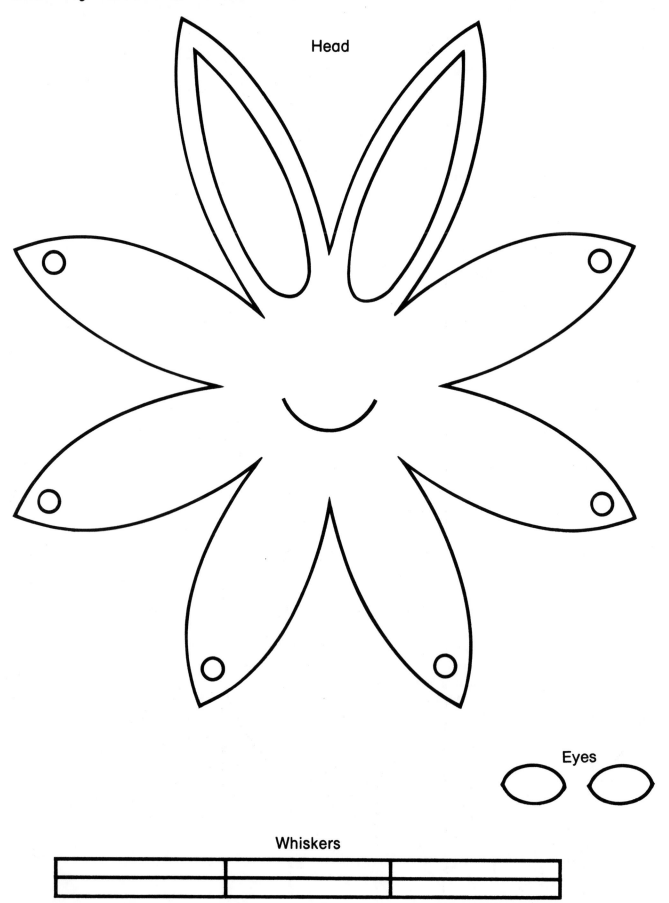

Head

Eyes

Whiskers

Art and Writing Throughout the Year © 1989

Bunny Basket Patterns

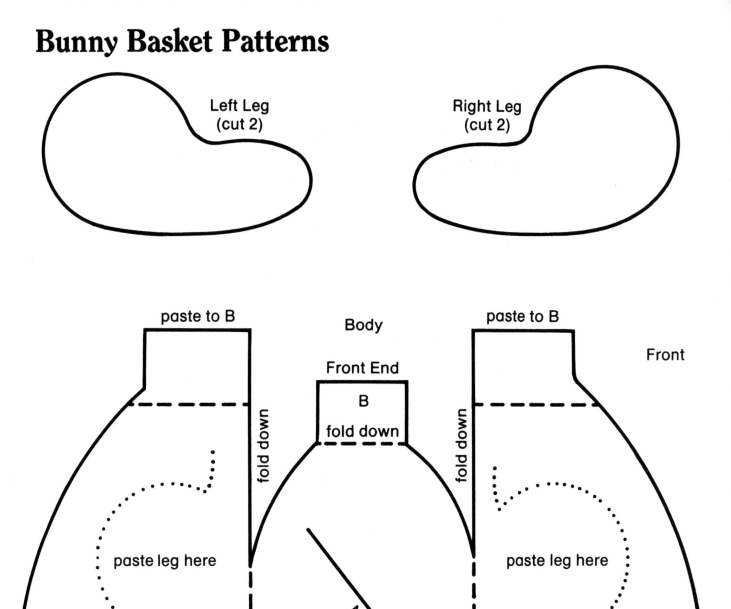

Left Leg
(cut 2)

Right Leg
(cut 2)

paste to B

Body

paste to B

Front

Front End

B

fold down

fold down

fold down

paste leg here

Name

paste leg here

paste leg here

paste leg here

fold down

paste to A

A

paste to A

Back

Back End

Cinco de Mayo

Cinco de Mayo commemorates a Mexican victory over France. In the United States, some Mexican American communities celebrate Cinco de Mayo with a fiesta. Parades and music from mariachi bands fill the streets. Games and food are readily available. If you wish, use the children's writing plans to plan a fiesta of your own. Play *juegos* (games) with your students as part of your celebration. One game, called *El Correo* (The Mail), can be played outside on a sunny May day. Mark spots in a circle and call each spot by the name of a Mexican or Latin American city. Have one child stand in the middle of the circle and call out the names of two cities. Players who are standing on these spots must change places. The middle child, and anyone else who wishes to, may try to take the places of the players as they move. Whoever is left without a spot must stand in the middle and call out two more place names. Piñatas also add a great deal of enjoyment. Ruben Sandoval's book *Games, Games, Games, Juegos, Juegos, Juegos* has the directions for many other fiesta games.

Using the Unit

Duplicate and hand out the primary or middle-grade writing plans (pages 147 or 148–149). If you wish, divide the class into groups and have each group plan their own fiesta celebration using the writing plans. The children should write the final versions of their invitations or brochures on clean pieces of paper.

Use the finished Fish Kites (page 150) when the children dance to music. The long paper tails will stream gracefully behind the children as they dance.

A Cinco de Mayo Celebration!

Cinco de Mayo is a special day in Mexican history that is celebrated on May 5. Plan a party for your class. Then use this page to help you write an invitation to the party.

Celebrate Cinco de Mayo!

Time _____

Date _____

Place _____

People organizing the party._____

What types of special Mexican foods will be served?

_____ _____

_____ _____

What types of games will be played? What are their Spanish names?

_____ _____

_____ _____

What should the guests bring to the party?

_____ _____

_____ _____

La Fiesta!

You are in charge of publicity for your school's Cinco de Mayo celebration. Your job is to write and design a brochure advertising the festival.

Who is presenting the festival?

Where will the festival be held?

When will it be held (time and date)?

Will students need to buy tickets? If so, how much do they cost?

List five things that people coming to the festival will see. Use vivid descriptive adjectives.

1. _____
2. _____
3. _____
4. _____
5. _____

List five things that people coming to the festival can do.

1. _____
2. _____
3. _____
4. _____
5. _____

Art and Writing Throughout the Year © 1989

La Fiesta! *(continued)*

List five things that people coming to the festival can eat.

1. _____
2. _____
3. _____
4. _____
5. _____

What pictures should be drawn or photographed for your brochure?

Reread what you have written. Look for the best way to put your information together into a brochure that will persuade people to come to the festival. Write the text for the brochure. Illustrate the brochure with a picture that shows something about the festival.

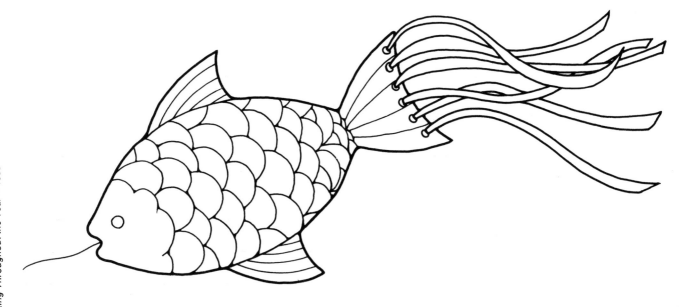

Fish Kites

Materials for Fish Kites

- Kite Pattern (page 151)
- Tagboard
- Colored crepe paper
- Yarn
- Paints or markers, scissors, tape, and hole punch

Teacher Preparation for Fish Kites

1. Duplicate the patterns for students to use as templates.
2. Cut the crepe paper into ½″ × 2′ strips. (See page 30 for quick cutting tip.)

Student Directions for Fish Kites

1. Either cut out the pattern and trace around it on a piece of tagboard, or tape the pattern onto the tagboard and cut out both together.
2. Punch holes in the tagboard fish where indicated on the pattern.
3. Draw or paint designs on both sides of the fish. (Rainbows of color are very effective, as are repeated patterns.) Let dry.
4. Thread a strip of crepe paper through each hole on the fish. Stop when you reach the midpoint of each strip. (There is no need to knot or tie the streamer in place—it will stay by itself.)
5. Thread a long piece of yarn through the eyehole of the fish. Tie the ends together.

Fish Kite Pattern

Mother's Day

Mothers today are often faced with multiple responsibilities at home and at work. The writing plans in this unit encourage children to thoughtfully consider all that the "special women" in their lives do for them on a daily basis. Younger students will fill out coupons which are active ways of saying thank you. Older students will write letters to their mothers, stepmothers, grandmothers, or aunts. (You can have the older children fill out the coupons also.)

Using the Unit

Start by having a discussion with the children about what qualities their mothers and their friends' mothers have in common and what makes each mother unique. (You should be sensitive to the feelings of children in your class who do not have living or present mothers. However, you can certainly talk about other "special women" in the children's lives.) If there is time, you should also discuss the role of grandmothers in the children's lives. Several well-written books about grandparents and grandchildren can inspire kids to write about their own grandparents. *First Snow,* by Helen Coutant and *Annie and the Old One,* by Miska Miles are particularly good choices.

After the discussion, duplicate and hand out the primary or middle-grade writing plans (pages 153 or 154). Ask the children to put a lot of care and thought into their coupons or letters. Have the older students write the final versions of their letters on clean pieces of stationery.

Once the students have finished writing, set up the materials for the Gothic Windows (page 155). Plan to have the children give the completed windows to their mothers, stepmothers, grandmothers, or aunts on Mother's Day.

Mother's Day Coupons

Give your mother, stepmother, favorite aunt, or grandmother something special on Mother's Day—super coupons for good deeds and extra help! Write your promises on the coupons below. Be specific.

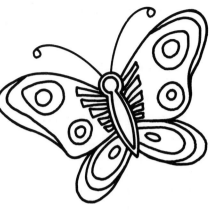

Extra-Help Coupon

For the next three mornings
I will

Bedtime Bonus

When it is time for me to go
to bed

No-Complaining Coupon

Hand me this coupon and
I won't

Good-Deed Day!

You need a day off, so I
will help

Super-Saver Coupon

This coupon is good for

Bonus Coupon

When you hand me this coupon,
I promise to

Dear Mom

In May we honor our mothers, grand-
mothers, and aunts—the women in our
lives who do so much for us every day.
Write a special thank-you letter to an
important woman in your life. Use the letter
to tell her how much you appreciate all that
she has done for you.

Who are you writing to? _____

Think of three ways in which this woman has helped you to
grow.

1. _____

2. _____

3. _____

Describe one time when she was particularly understanding.

Explain how her love and support have helped you.

What traits does this woman have that you would like to have
when you get older?

Reread what you have written. Think about the best way to
put the information together into a thank-you letter. Write
your letter.

Art and Writing Throughout the Year © 1989

Gothic Windows

Materials for Gothic Windows

- Pattern (page 156)
- Pastel or dark construction paper
- Onionskin paper
- Foil
- Warming tray
- Old crayons
- Gold and silver crayons
- Scissors, transparent tape, and masking tape
- Paper towels

Teacher Preparation for Gothic Windows

1. Duplicate the arch patterns.

2. Line a warming tray with foil and turn the tray to the "low" setting.

3. Place masking tape across the center of the tray to divide the tray into two working areas.

4. Remove the wrappers from the crayons. Place the crayons in several bowls, grouping them by color. For example, put the pinks and purples in one bowl; the blues and greens in one bowl; and the yellows, oranges, and reds in one bowl.

Student Directions for Gothic Windows

1. Fold a piece of construction paper in half lengthwise.

2. Cut out the arch pattern and place it along the fold of the construction paper. Trace around the pattern and cut out.

3. With crayons slowly draw an abstract design on the warm foil. (The wax will melt and blend together.) Add a few touches of gold or silver.

4. Carefully place the onionskin paper over the design. Press down with a can or cup to protect your fingers. Then, very carefully, lift off the paper. Place it to one side to cool.

5. Wipe the tray clean with a paper towel for the next student.

6. Tape the crayon drawing to the back of the construction-paper arch.

Gothic Arch Pattern

place on fold

Art and Writing Throughout the Year © 1989

Father's Day

In order to avoid hurting the feelings of children from divorced families, and because the holiday comes at the end of the school year, many teachers seem to avoid Father's Day. This is a mistake. We should use every possible opportunity to help children appreciate their parents, just as we help parents appreciate their children. Like the Mother's Day unit, this unit is designed to let children say thank you to a father, grandfather, uncle, or any other special man in their lives.

Using the Unit

Have the class make the San Francisco Row Houses (page 161). The students should fill the flower boxes with bright tissue balls and spend time drawing the architectural details with care. Since the doors and windows of the houses open, ask the children to draw detailed pictures for the inside scenes. Plan to have the children wrap the houses as gifts for their families.

For younger children, duplicate and hand out Father's Day Biographies (page 158). When the children have finished their rough drafts, ask them to write their final drafts on a clean sheet of paper. Ask the children to give their special men the biographies when they give them the houses.

For older children, duplicate and hand out the middle-grade writing plan (pages 159-160). Discuss interviews and newspaper articles. You might bring in some feature articles about community people to use as examples of good and bad feature writing. The children should use the writing plan as a guideline for conducting the interview. Then, they should use the information gained from the interview to write a feature article on their special man. The students may refer to the plans when they write their articles.

Father's Day Biographies

Why is your father, stepfather, favorite uncle, or grandfather special? Use this page to help you write a biography of a special man in your life.

This biography is about my _____ , Mr. _____ .

Mr. _____ is _____ years old. He lives in

_____ . He likes to eat _____

for breakfast. He likes to play _____ . He

also likes to _____ .

Mr. _____ is a very _____ man.

For example, he will _____

_____ .

When I think of him, I think of _____

_____ .

He is special to me because _____

_____ .

I want to wish Mr. _____ a very happy Father's Day!

Art and Writing Throughout the Year © 1989

Extra, Extra, Read All About It!

You are a newspaper reporter. Your job is to interview a man in your family for a special Father's Day edition of the local paper.

Ask the man the questions on these pages. Remember, you do not need to write down everything he says—instead, take notes on the important parts to help you write the article later. You can make up additional questions if you wish.

What do you remember best about your own father? About your grandfather? Was there another man (an uncle, stepfather, or family friend) who spent a lot of time with you as a child?

When you were a boy, how did you think the perfect father would act?

What do you like best about the work you do? What do you like least?

What do you like to do on weekends? What household chores do you like the least?

Extra, Extra, Read All About It! *(continued)*

What do you remember best about the times we spent together
when I was small?

What advice can you give me about being a parent? What do I
need to learn to prepare myself for that important job?

What people have influenced you and how?

What do you wish you had done differently in the recent past?
What changes in your life do you think you might make in the
near future?

Reread what you have written. Look for the best way to put
your information together into an article about the man you
interviewed. (In newspaper writing, a good article tells who,
what, where, when, and why.) Use quotes in your article and
remember to start the article with a good lead sentence.

San Francisco Row Houses

Materials for Row Houses

- Exterior patterns (pages 163–165)
- Interior pattern (page 166)
- Pastel construction paper, any color except yellow
- White construction paper
- Markers
- Tissue paper: dark green and vivid colors
- Glue, small sharp scissors, and stapler

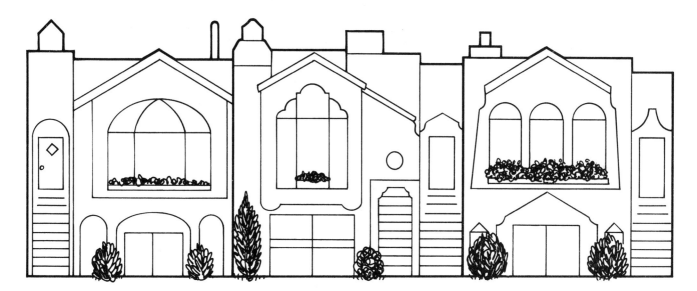

Teacher Preparation for Row Houses

1. Duplicate the exterior patterns on pastel construction paper. Make a number of each pattern so each child can choose the pattern that he or she wants to use.
2. Duplicate the interior pattern on white construction paper. Make one copy for each student.
3. Cut the tissue paper into 1½″ squares. (See page 128 for tips on how to do this quickly.)

Student Directions for Row Houses

1. Pick the pattern you wish to use. Then trace around the solid lines with a marker. Use a marker that is a darker shade of the construction paper color.
2. Add your own design elements to the house. For example, you might color in the tops of the windows, draw designs on the front door or garage door, or add details such as doorknobs.
3. Roll small balls of tissue paper in your palms and glue them in the window box to represent greens and flowers.
4. Make a bush or tree for the front of the house. To do this, place pencil eraser in the center of a tissue square. Pinch the tissue up. Dip eraser into paste. Press onto house. Repeat several times, pasting pinched paper squares close together to create bush or tree.
5. Draw interior scenes on the interior pattern.
6. Cut out both patterns.

Teacher Directions for Row Houses

1. After students have finished drawing and cutting out the patterns, use scissors to cut open the doors and windows as indicated on the patterns.

2. Fold the interior patterns along the fold lines to form hinges.

3. Staple the exterior patterns to the interior patterns where indicated. The two patterns should stand away from each other as shown.

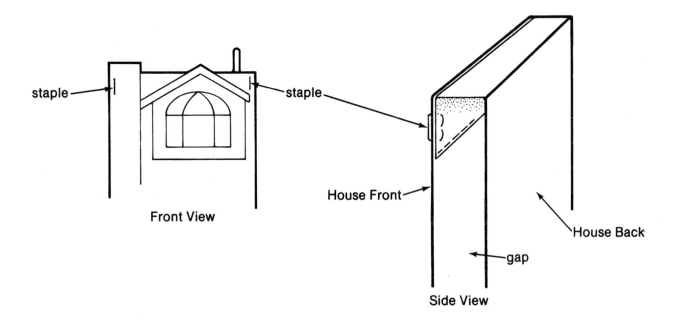

Front View

House Front

House Back

gap

Side View

San Francisco House Pattern

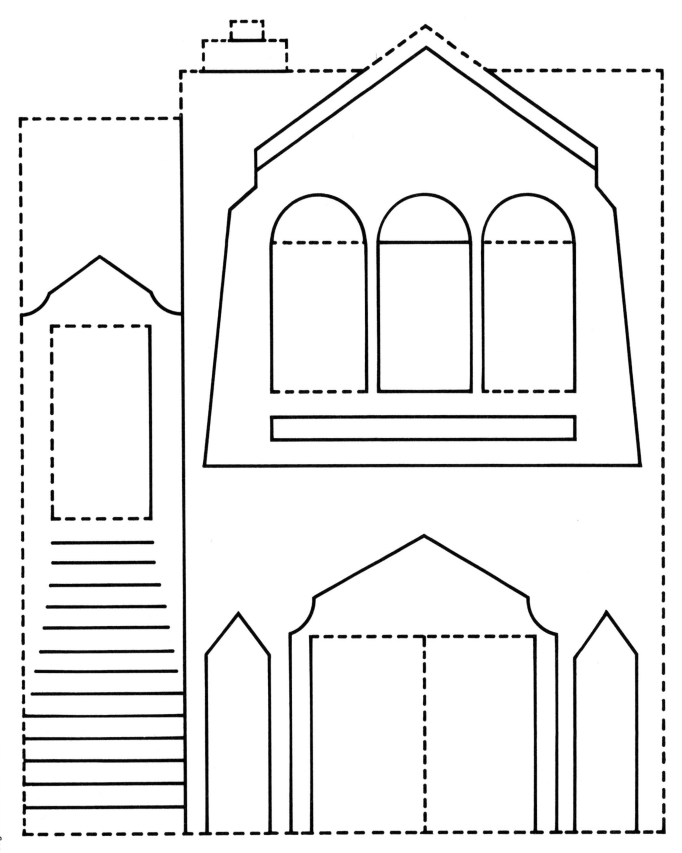

Art and Writing Throughout the Year © 1989

San Francisco House Pattern

San Francisco House Pattern

Interior House Pattern

staple

staple

fold

fold

Art and Writing Throughout the Year © 1989

The Joys of June

In June, teachers and students look back on the past school year with nostalgia and contemplate the coming year with somewhat mixed feelings. Certain rituals can be very comforting for all concerned at this time of year. I make teacher evaluations a ritual in my classroom. No one can tell you how to change, what to order, or how to meet the needs of your students better than the children themselves. Even though children particularly want to please you, they are both frank and honest. The following are some of the responses that I have gotten using teacher evaluation forms.

What was the most important thing you learned this year?

"The most important thing was reading. I will love reading all my life."

"I have learned not to show off because it really annoys people."

"Math is the most important thing I learned because you need it all your life."

"The most important thing I learned this year was how to communicate with other people."

What was the most difficult part of this year for you?

"The most difficult part of this year has been science. I really don't know much about the subject."

"Long division was hard but I'm getting to know it better."

"Reading is hard. I was always in the third highest reading group and my test was so good this year I got to go to the second highest group. What a hit! My new book is funny, scary, and sad, too."

If you could wave a magic wand over the classroom, what changes would you make?

"I would like not to have our balls go up on the roof at recess."

"I would have more cracker games like the ones we had for fractions. They were good crackers."

"I like reading because it gives thoughts to your mind. I would like to wave my wand and extend the book supply."

June is also the time to write and illustrate beautiful thank-you cards to all the unsung heroes of elementary school: the secretary, the janitor, yard-duty people, room mothers, cafeteria helpers, and librarians. The Flower Thank-You Cards in this unit are perfect for this.

Using the Unit

The primary and middle-grade plans (page 168 or 169) in this unit are sample evaluation forms. If you wish, you may modify them to fit your own needs before you duplicate them and hand them out to the children. In addition to questions about the curriculum, you might add questions about classroom procedures and policies. Remember, a lot of learning goes on outside the confines of specific subject areas.

The Flower Thank-You Cards (page 170) take little teacher preparation time, but be sure to make one yourself first so you will know what's involved. The tissue paper camellias (page 130) also work well on cards.

To My Teacher

Our year together is almost over. Write me a letter. I will keep this letter to remember you by. I will use your ideas when I teach future classes.

Dear _____,

This year I really enjoyed _____

I learned a lot about _____

However, it was hard for me to _____

Next year, I think you should _____

Love,

Art and Writing Throughout the Year © 1989

Teaching the Teacher

What did you like about our class this year?
What didn't you like? Help me plan for next
year's class by filling out this form. Use the
back of the page if you need more room.

What was the most important thing you learned this year?

What was the most difficult part of this year for you?

What did we do together this year that you most enjoyed?

What was your favorite subject? Why was it interesting?

What was your least favorite subject? Why was it boring or
hard?

If you could wave a magic wand over the classroom, what
changes would you make?

Flower Thank-You Cards

Materials for Thank-You Cards

- Daffodil pattern (page 171)
- Yellow crepe paper
- Construction paper: green and blue
- Tissue paper: orange and yellow
- Paste, stapler, and scissors

Teacher Preparation for Thank-You Cards

1. Duplicate several copies of the Daffodil Pattern. Duplicate on green construction paper enough Leaves and Stems Patterns so that each child has one set.

2. Staple the Daffodil Patterns to two layers of yellow crepe paper. Use a paper cutter to cut along the lines on the pattern. This should give each child enough petals for two cards.

3. Cut the yellow and orange tissue paper into 2½" squares. Make enough so that each child has a yellow and an orange square.

Student Directions for Thank-You Cards

1. Cut out the green leaves and stems.

2. Cut out the circle pattern to use as a template.

3. Cut out the yellow petals by cutting through the pattern and layers of crepe paper. Separate petals carefully.

4. Place the green circle on top of a yellow and an orange tissue paper squares. Trace around the circle and cut through both pieces of tissue.

5. Paste the yellow and orange circles together with a small dab of paste.

6. Arrange the stems, leaves, and petals on the blue construction paper. Paste in place.

7. Make the flower center by placing a pencil eraser in the middle of the tissue circles. Carefully pinch the tissue toward the pencil. Dip eraser in paste and press onto flower petals.

Place pencil in the center of the circle.

Pinch tissue.

Dip in paste.

Press on flower.

Lift pencil out.

Daffodil Pattern

Leaves and Stems

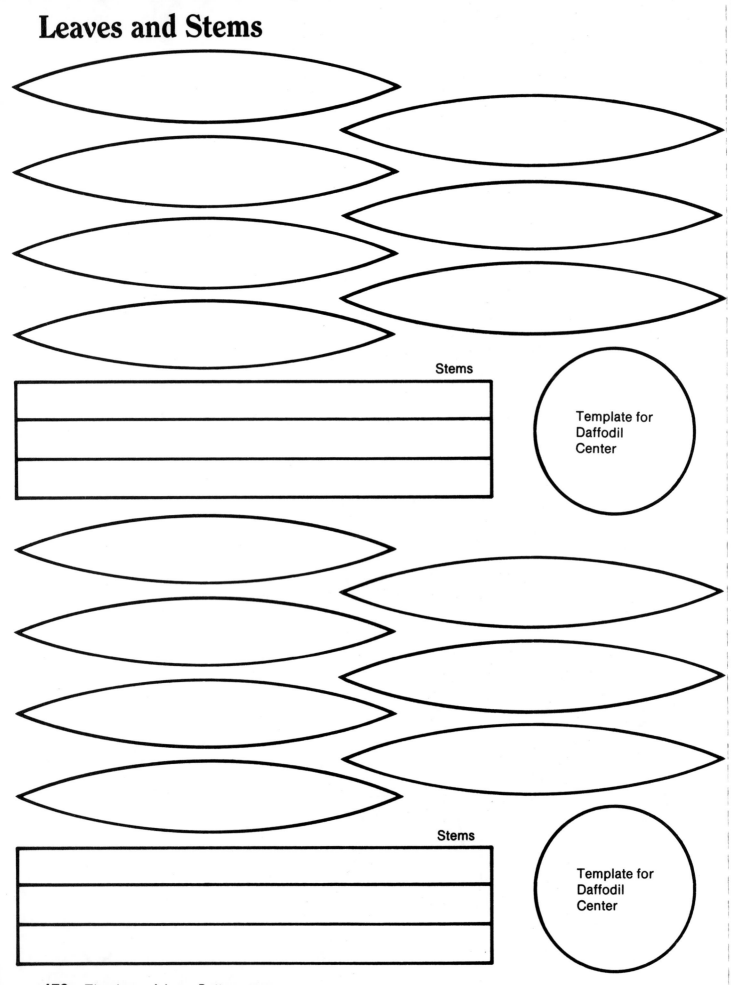

Stems

Template for Daffodil Center

Stems

Template for Daffodil Center

APPENDICES

Appendix A: Lexicons and Study Buddies

A SPELLER FOR ALL SEASONS

Poor spellers learn to fear writing soon after the second grade. Many children may write fearlessly for several years using nonstandard spelling, but as they begin to recognize their errors, they begin to avoid writing altogether. I once taught a first-grader who wrote ten or twelve pages in her journal each day. She spelled everything phonetically (according to her own interpretation). Fun was spelled p-h-u-n, actually was a-k-c-h-w-a-l-l-i-e, and Ellen was E-l-i-n. Once I learned her code, I was able to read and enjoy her stories easily.

Unfortunately, first and second graders cannot use lexicons and personalized spelling lists easily. However, you can individualize spelling in these early grades using 3″ × 5″ index cards. I give each child a box of cards on which I have written the correct form of words that were misspelled in actual writing done by the student. These cards are then used in spelling games and practice drills. (Advanced students can put them in ABC order.)

From third grade on, students can use a lexicon for writing. I ask children to bring in a 5″ × 7″ address book at the beginning of the school year. (Address books are perfect for personalized spelling lists because they are already in alphabetical order.) The address books become the students' lexicons.

I use lexicons in two ways. First, when a student wants a word spelled when working on a final draft, I allow the student to come quietly up to my desk and wait until he or she catches my eye. The student should have the address book open to the appropriate page and a pen in hand. The child simply says the word to be spelled, for instance, "miracle," and hands me the book. I write the word in the book and hand it back. A "thank-you" is permitted, and the child returns to his or her seat. This method cuts down on unnecessary interruptions for the rest of the class.

The second way I use lexicons involves corrected student writings. When corrected work is handed back to the students, I ask them to copy the right form of the misspelled words into their lexicons. (Students will sometimes miscopy, so I ask parents and study buddies to help me check the copying, which cuts down on the error rate.) Caution: Do *not* ask students to spell correctly in first draft writing. It gets in the way!

I use lexicon entries for challenge words on spelling tests. Every Monday and Friday I ask one student to volunteer his or her lexicon. I choose five words at random and write them on the blackboard. (I use a heading which reads "_____'s words." The blank gets filled in with the volunteer's name. This is an excellent way to teach apostrophes.) If any children misspell the challenge words on the test, it does not lower their test grades significantly. However, they have to copy the misspelled words into their lexicons. Eventually, there is a large common pool of words in the class lexicons.

THE STUDY-BUDDY SYSTEM

While teaching English as a foreign language in Japan, I worked with a Japanese English teacher in a junior high school. The teachers on the faculty were generally excellent, but to an outsider, the most impresssive feature of the school was the cooperative spirit that existed among its students. Japanese children are used to working in teams, while American students tend to value competition over cooperation. The study-buddy system is one that teaches cooperation. The following are the basics of the system.

1. Placement and Seating

The study-buddy pairings should reflect a complementary balance of academic ability, social grace, athletic ability, and emotional maturity. The combination will allow children to draw on each other's differing strengths. Choose pairs of study buddies carefully. Have the children sit two-by-two in double rows or in groups of four or six desks. Change assignments often and be sure to have mixed-sex buddy pairs. If for some reason a child is particularly unhappy with his or her placement, the child should make an appointment with you to discuss the matter.

2. The Expectations of the Study-Buddy System

The expectations of study buddies are academic *and* social. Buddies are expected to collect homework and/or handouts for absent buddies; to help their buddies understand particular assignments if they can; to help each other with drill and practice using flashcards (this is particularly helpful with math facts and science or history vocabulary); and to help each other revise written work by asking for clarification when thoughts are incompletely expressed. They are also expected to involve their buddies in games and to try to help build self-esteem. For example, if a student failed last month's science test and earned a C- on this month's test, that student's study buddy might congratulate him or her on the improved results or write a note of encouragement.

Be sure you explain the reasons for and the importance of the study-buddy system to the children. Point out that if children limit their friendships to members of their own sex, they cut themselves off from half the class. Ask the class to approach the study-buddy relationship with an open mind. Tell them that when a new assignment is made, they should greet their new buddies in a positive manner—that it is not "cool" to treat any classmate with disrespect.

3. Affirming the Study-Buddy Relationship

Recognize the efforts of children who are supportive of one another. Comment frequently to individuals and to the class pointing out evidence of supportive behavior. Show through your own actions that you value cooperation highly and that cooperative children are "stars" in your classroom.

At the end of each quarter, I award "Study-Buddy Certificates." These certificates are presented to the team (or teams) that has worked most effectively together. I talk to the children about cooperation and encourage the honored children to make speeches about what they have learned from each other. One child's response to the study-buddy system was, "Study buddies are the best idea any school ever had. I would have learned only half as much this year if I didn't have my buddies to help me."

Appendix B: Seasonal Reading Trees

I usually put up my Reading Tree in September before the children arrive. In August, I send each child on my class list a short personal note. One of the questions I ask in this note is, "Have you read any good books this summer?" If the children answer me before class begins, and many do, I use their responses for the first leaves on the tree. Generally, with younger children, each book that is read is represented by one leaf on the tree. With older children, a leaf represents 200–300 pages read. As a class, we set a goal of 100 leaves for the class tree. When the goal has been met, the tree "sheds" its leaves and we celebrate with a party. If possible, I make it a literary party by inviting a local author or journalist to the party.

THE BASIC READING TREE

What You Need:
- Pattern (page 178)
- Brown or black tagboard
- Clear Con-Tact paper
- Butcher paper
- Opaque or overhead projector
- Scissors

Directions

1. Enlarge the pattern to the desired size. To do this, place the pattern on an opaque projector or a transparency of the pattern on an overhead projector. Tape large pieces of butcher paper onto the wall where the pattern is projected. Focus the image, then trace the image onto the butcher paper.

2. Use the butcher-paper pattern to make a template. Cut out the butcher-paper tree. Trace around each piece onto the back of the brown or black tagboard. Cut out the tagboard pieces.

3. Laminate the tagboard pieces with clear Con-Tact paper. (This is important if you are going to use the tree all year.)

4. Set up the appropriate seasonal background (see descriptions that follow) and position and pin the tree pieces to the background. Add seasonal details.

THE AUTUMN TREE

Set up the tree pieces on a classroom door or wall. Make a starting set of leaves out of fall colors on construction paper. If you have obtained book titles from the children before class starts, write the title of each book and the child's name on a leaf. Tape the leaves over and under the branches of the tree. Make some extra leaves to place at the bottom on the trunk.

Once the school year has started, ask children to make a leaf each time they have finished a book (or a set number of pages in a book). They should write the book title, number of pages read (if appropriate), and their names on the leaves. Let the children tape the leaves to the tree, in the "air" next to the tree, and on the ground below the tree. If you wish, children may use construction-paper apples as reading records also.

THE WINTER TREE

Tape or staple large pieces of gray, dark blue, or purple construction paper to a wall or door. Position and tape the tree pieces to the construction paper. Use cotton or white construction paper to make "snow" over the base of the tree and in the branches of the tree. Have the children make cut-paper snowflakes to use as reading records.

THE VALENTINE'S TREE

Tape or staple large pieces of white construction paper to a wall or door. Position and tape the tree pieces to the construction paper. Have the children decorate the tree with Special Valentines (see page 127).

THE SPRING TREE

Tape or staple large pieces of pastel blue or green construction paper to a wall or door. Position and tape the tree pieces to the construction paper. Make "grass" out of green construction-paper strips placed at the base of the tree. Decorate the tree with tissue-paper flowers (see Special Valentines, page 127). Have the children write the reading records on thin, light green construction-paper leaves. If you wish, decorate the scene around the tree with Spring Birds (page 134), Butterflies with Shadow Wings (page 136), and Daffodils (page 171).

THE SUMMER TREE

Tape or staple large pieces of bright yellow or blue construction paper to a wall or door. Position and tape the tree pieces to the construction paper. Use vivid colors of tissue paper to make tissue-paper flowers. Add bright green leaves and grass. Brainstorm with your summer-school class to come up with summer symbols to use as reading records.

Seasonal Reading-Tree Pattern

Art and Writing Throughout the Year © 1989

Appendix C: Autobiographies

End-of-the-year autobiographies are particularly important in my middle-grade classes. They give each child a chance to show off, since the final books are definitely something to be proud of. While this project can be done at any time of the year, I prefer to start it in April. If students have written extensively throughout the rest of the year, they have probably begun to think of themselves as writers. By April, they should be able to write a book on the subject they know best—themselves.

Organization is the key to success for this assignment. I divide the assignment into eight parts—an introduction, five chapters, a conclusion, and the final revisions and assembly. Each chapter is usually four or five pages long. I give the children a week to do each part. It is helpful to go through the whole assignment first, before children begin their work. The week the books are due is a special occasion in my classroom—complete with an "Authors' Faire" and a tea for parents.

THE AUTOBIOGRAPHY ASSIGNMENTS

I start by handing out the Autobiography Process (pages 184-185) and going over it step-by-step. Then I describe each part of the assignment in detail and follow up the discussion with the assignment writing plans (pages 186-200). The following are descriptions of the different autobiography parts:

Assignment A: Beginning the Book (Introduction)

Explain to the children that they should start their autobiographies by writing a four page introduction.

Page one should be the title page. This page should contain the title of the book, the child's full name, the due date of the book, and an illustration. Point out that the children should be inventive with their titles—they should not call the book "My Autobiography."

Page two should be a dedication page. Explain that dedicating a book gives the children a chance to honor a special person or even several people. Tell the children to be specific about why they have chosen a particular family member or friend. For example, they might write, "I dedicate this book to Uncle Horace. He has taken me to a baseball game every summer since I was three. He always buys me a hot dog at the game and plays catch with me afterwards."

Page three is a quotation page. Ask the children to pick a poem or a part of a story they particularly like. Explain that they should use whatever space they think is necessary—the quotation does not have to take up a whole page.

Page four is the foreword. Tell the students that this page should contain one short, but eloquent, paragraph about themselves. The purpose of the foreword is to introduce the reader to the author.

Assignment B: The Family Survey (Chapter 1)

Tell the class that the first chapter in their autobiographies should be about the history of their families. Explain that they need to find out everything they can about their family backgrounds. Point out that one way to do this is to ask parents and/or grandparents questions about their lives. Have the children ask their parents and/or grandparents the questions on the first two pages of the writing plan. They can then use the answers to fill in the final page of the plan and to write the chapter.

This chapter should be illustrated with a drawing of an ancestor. If children can't find an old photograph to use as a reference, suggest that they look up pictures of old-fashioned dress in an encyclopedia.

Assignment C: The Primary Years *(Chapter 2)*

This chapter should be about the children's first years in school. Tell the children that it should be written in chronological order—either starting with their current grade in school and working backward, or starting with their first year in school and working forward. Remind students to include a discussion of preschool, daycare, and summer school if it is applicable.

Ask the children to illustrate this chapter with a step drawing. Explain that the drawing should have at least three parts—the student as a baby, as a child of two or three, and as the child he or she is today. If they wish, the children can extrapolate further, showing themselves as young teenagers.

Assignment D: A Family Scrapbook *(Chapter 3)*

Tell the children that a scrapbook is a book filled with various items, such as letters, newspaper clippings, recipes, and pictures. Explain that this chapter will be a written scrapbook about life in the children's families. The children should write about the holidays and special traditions the family celebrates, what the family does on vacations, what types of responsibilities the child has in his or her family, and so on.

Have the children illustrate the chapter with a holiday drawing. They should include family members in the picture.

Assignment E: Memories of Favorite Things *(Chapter 4)*

This chapter should focus on the children's hobbies and the moments in their lives that they will never forget. Ask the children to think about the different things they enjoy doing and about the things they do well.

This chapter could also include a short poem about one of the child's hobbies. The poem should be illustrated. If the children have a hobby they can share, such as sculpture or weaving, you might have them turn in a sample of their work rather than writing the poem.

Assignment F: Thoughts About the Future *(Chapter 5)*

This chapter consists of drawings and captions. The students should imagine how they will look and what they might be doing ten, twenty, thirty, forty, and fifty years from now. Then they should draw a picture of each phase, each on a separate piece of paper. For example, if they see themselves as parents at age thirty, they could draw themselves holding the hand of a small child. Or, if they see themselves as astronauts at age forty, they could draw themselves in spacesuits, with rockets in the background.

Ask the children to leave the bottom two inches of the art paper blank for the caption. Explain that they should number the pictures and then write a three to four line description for each picture on lined paper. (These will be cut out.) Each child should write in the present tense, as if the picture were a true picture of the child at that age. For example, one caption might read, "At thirty, I am now the father of two little girls, ages five and seven. I play third base for the Detroit Tigers baseball team for a living. After work I play the cello for fun."

Tell the children to write captions on a separate piece of paper first, and to proofread their captions before pasting the cutout sentences below the pictures.

Assignment G: The Conclusion

The conclusion should be a single paragraph. It should tell the reader what the child has learned about himself or herself while writing the autobiography. It should also talk about what the child has learned about the process of writing.

I usually have the children turn in the conclusion with Chapter 5. If you do this, remind the children to write the conclusion on a separate piece of paper and to title the page.

Assignment H: Assembling the Book and Final Revisions

Have the children construct a cover for their books. The covers should include the title of the book, the child's name, and an illustration. Tell the class not to use plastic report covers. (The book will be too thick for these.) Then have the children put their chapters in order and number the pages in the upper right-hand corner.

If you wish, have the students turn in a self-evaluation form with the book. I usually ask my students to give themselves a plus, a check, or a minus in each of the following areas: effort, neatness, artwork, organization, and style.

THE AUTHORS' FAIRE AND THE PARENTS' TEA

Sometimes, when stories that have been authored by children are completed, they are simply graded and set aside. Students who have worked diligently for some months and have produced a book of their own, deserve recognition for their efforts. In E. B. White's *Charlotte's Web,* Charlotte tells Wilbur that she felt that her egg sac was her magnum opus. Many young writers in my class felt the same way about their autobiographies.

With this in mind, I spend a great deal of time on the autobiographies the week they are due. The weekend before the final books are turned in, I take the whole basket of folders home to read. (Of course I have been reading student work in progress each week and helping students to revise before this.) This last weekend, I take notes on the finished chapters and type up highlights from each book-in-progress. I always include something from each child's book in the highlights, and I have the children take copies of the highlights home, along with a letter, to their parents. In the preface to the parent letter this year, I wrote, "The passages chosen from each child's book were picked for two reasons. First, they were enticing because they were well written or because the information was inherently interesting. Second, in each selection it is possible to hear the voice of the child who is the author."

In a class of 35-40 students, the highlights are generally seven or eight pages long. Each child reads his or her passage aloud to the class. Then the children roll up the pages scroll fashion, tie them with a ribbon, and put them immediately in their backpacks to take home and share with their parents.

The day the books are due, I try to meet with each student for a few minutes. I ask each child what he or she thinks is the best part of his or her book, and then we read some part of that chapter aloud together.

In the afternoon I distribute three 5" × 7" cards to each student. On the first card they copy the inspirational quotations they used in their introductions. I always ask the students to include on these cards the words "selected by" and their own names, as well as the authors' names. I like to have these cards for two reasons: the next year's students enjoy reading them, and they can be used in the classroom as "Thoughts for the Day."

The other two cards are used in a trivia game that is played a few days later. I have each student write five questions about himself that can be answered by a careful reading of the autobiographies. I ask the students to think about their questions and phrase them carefully, for example, "What was Chong's favorite food when

he was three?" or "How did Julie feel when her dog was run over by a car?" The children are soon able to ask different types of questions, and usually their cards contain at least one question that asks for more than simple recall. Answers are written on the backs of the cards.

The next day I give the children 45 minutes to read each other's books. This is usually not enough time, so I open the classroom at lunch once or twice during the week for eager students. I require that they be absolutely silent so they will not disturb my lunch break as I work at my desk. (Noisy children are punished by being sent back outside to play!) This year not even sockball could compete with the autobiographies. Out of thirty-six students, thirty chose to sprawl in all sorts of contortionist positions on the rug and under the art table during the lunch period to read the books.

Before I set out the books to be read, I stick a loose sheet of paper in the back of each book and title it "Critical Acclaim." Each time a child or adult reads the book, they are expected to make a comment on this page. (Of course, negative comments are strictly forbidden!) By the end of the week, most of the students should have read and commented on at least half of the autobiographies.

The highlight of the week is the Authors' Faire. I start the Faire by playing Author Trivia. I usually divide the class into four teams. Each group chooses a name for their team and I choose a captain. I also choose one student to act as a scorekeeper for the whole class.

I shuffle the 5" × 7" question cards and read off a question. The team captain picks one member of his or her team to answer the question. After a few seconds, I ring a bell and the child must answer the question. If an incorrect response is given, the child is allowed to consult with the other team members. Two points are given for each question answered correctly the first time around, and one point is given for a team-answered question. It is against the rules for a student to answer a question about his or her own book.

The children enjoy this game and they learn a lot about each other as they play. When the game is over, the books are set up in the classroom library area and treats are set out for parents.

As soon as school is over for the day, I quickly head to the faculty room to make tea. By the time I return to the classroom, it is usually filled with teachers and parents for the Parents' Tea. The children who choose to stay serve the parents tea and cookies, and then everyone settles down to read the autobiographies. The parents often write very insightful and touching comments on the Critical Acclaim pages. Many come expecting to stay for a few minutes and end up staying until 5:00, when I pick up the teacups and bid everyone a fond farewell.

SOME AUTOBIOGRAPHY HIGHLIGHTS

The following selections were chosen because they were particularly well written, funny, or touching. All of them came from one class of fourth-grade students.

When my mom was a kid she loved horses. She would ride horses, draw horses, and pretend she was a horse. She used to dream about owning her own horse at Bobby Benson's Bee Bar Bee Ranch, a ranch talked about on one of her favorite radio programs. Now that my mom is middle-aged, she thinks it would be expensive and highly impractical to own a horse.

(From *Clouds and Rainbows,* by Christina Luini)

Through the pages of this book, all your thoughts will be on just one person, Molly Horan. I am Molly. I hope when you have finished this novel, you will like to do what I do best: being daring, loving others, and achieving much.
(From *Life as the Youngest,* by Molly Horan)

In preschool my thoughts were full of playing and fun. I had little time for listening and learning. In kindergarten I was more into books and learning, and thought of playtime as extra time. In first grade I thought I was very grown up because I was stepping into the world of books, an important part of a human child's life.
(From *Hidden Feelings,* by Christina Courtright)

Second grade was not bad. I caught on quick. It was still the same old thing, but it got harder. Nobody said second grade was a rose garden.
(From *The Life of a Ten-Year-Old Boy,* by Errol Carreon)

One of my teacher's best things is this book you are reading right now!
(From *Awesome Alexis,* by Alexis Dunnigan)

My great-grandmother got food by going out in the yard and chasing a plump chicken with a stick. She hit it on the head, chopped off its head, boiled water, plucked its feathers, and cooked it.
(From *Casey at the Bat,* by Casey Farrelly)

People want to know about other people's lives a lot. Remember, this is a true story. Some parts may be funny, in case children are reading.
(From *Skinny Bones,* by Noel Bernabe)

The early years of my life have been exciting at times, challenging at times, miserable at times, and surprising at times. My first grade teacher had a voice that would echo through the whole school, she was quite boisterous. My next teacher was the opposite, she was in the hugging business. We felt happy around her, she made us feel comforted.
(From *The Little Theater of My Life,* by Maria Leonard)

This year I have learned that nothing is impossible. If I really have the desire to accomplish anything in my life, I can do it. It just takes hard work and determination.
(From *The Tooth Fairy Never Stops Here,* by Beth Horan)

This is my original and so far my only book. This ends my book, even though I've only lived 1/9 of my life . . . good life, good book, goodbye!
(From *An Original,* by Derrick Lee)

This book is about me, the good times and the bad. It is about how I grew up, what I played, how I got along with people, and how I did things. . . . So now you know about my life, its faults and its successes, the excitements and the bores. Thus ends the story of me.
(From *The Good Times and the Bad,* by Stephen Jonas)

The Autobiography Process

Writing the Book

1. Read each assignment carefully. Follow the directions for each step.

2. Work quietly at school, and later, if necessary, at home. Make sure you have all your pencils, erasers, and paper before you begin to work.

3. Close your eyes. Think about what you want to say. Talk to a friend about it if you wish. Use the writing plans to help you get started.

4. Write the rough draft. Each chapter should be about four or five pages long. Skip lines as you write, so you can make corrections easily. Be sure to indent each new paragraph.

5. Keep your lexicon or a dictionary handy, so you can look up the correct spellings of difficult words.

6. Reread what you have written. First read it to yourself, silently. Then read it aloud to a friend, quietly. Each time you read, revise—make it better. Correct in pencil and use your eraser freely.

7. Do something physical. If you are at home, ride your bike or play catch. Do not think about your work for a while.

8. Illustrate the chapter. Some people find it easier to organize their thoughts while they draw. If you are one of those people, you might want to illustrate the chapter before writing it.

9. Clip, do not staple, your pages together. Turn in your work for teacher comments.

10. After you receive comments on your work, add further corrections and revisions. Then neatly copy over the messy pages onto clean pieces of paper.

Art and Writing Throughout the Year © 1989

Assembling the Book

1. Construct a cover. Make sure the cover includes your title, your name, and an illustration.

2. Put your chapters in order. Use an eraser to remove any stray marks. Read through your book to see if there are any small, last minute changes you wish to make.

3. Number all your pages in the upper right-hand corner.

4. Secure your pages in the cover. Then thumb through your book carefully to make sure that all the pictures and pages are secure. Remember, other people will be reading your book, so you don't want it to fall apart.

5. Hold your book in your hands and think about all you have accomplished in the last two months. Did you ever think you would someday write a whole book yourself?

Art and Writing Throughout the Year © 1989

Beginning the Book (Introduction)

You are about to write a long book about yourself. It will have an introduction, five chapters, and a conclusion. These pages are planning sheets. Use them to make decisions about the first four pages of your book.

The Title Page (page 1)

What is the title of your book? _____

How will you write your name as author? _____

What is the due date of your book? _____

What is a good illustration for this page? _____

The Dedication Page (page 2)

Is there someone special you want to dedicate your book to? Write the person's name and list three reasons why this person is special to you.

Name: _____

1. _____

2. _____

3. _____

The Quotation Page (page 3)

Is there a poem, a verse or line from a song, or a part of a short story that you think would make an appropriate quotation for your book? Write the title of the poem, song, or story and the name of the author.

Title: _____

Author: _____

Art and Writing Throughout the Year © 1989

Beginning the Book (continued)

Foreword (page 4)

Why are you writing this book?

List some reasons why you think the reader should read your book.

Describe what the reader will learn about you once he or she has read your book.

Write an opening sentence that introduces yourself or your book to the reader.

Reread your ideas. Use these ideas to help you write the introduction to your book. Write each part on a separate page.

The Family Survey (CHAPTER 1)

What were your parents and/or grandparents like when they were your age? Did they like the same foods that you like now? Did they imagine that they would have the jobs that they do? How did they feel when you were born or adopted?

Ask your parents and/or grandparents the questions on the first three pages of this writing plan, and then use the fourth page to help you organize your thoughts. You can make up additional questions if you wish.

What three things do you remember best about your childhood?

Where did you live as a child? If you moved when you were young, how did your life change when you moved?

Art and Writing Throughout the Year © 1989

The Family Survey *(continued)*

How has life changed for children since you were young?
Was your elementary school different from mine? Did you eat
different foods or wear different clothes? Did children like to
do different things?

What did you dream about when you were a child? Did your
dreams come true? How have your dreams changed over the
years?

Do you remember any stories that your parents or grand-
parents told you about their childhoods? If so, which one do
you remember best?

The Family Survey (continued)

Who do you think was or is the most fascinating person in our family? Why?

How and when did you meet my father/mother or grandfather/grandmother?

What do you remember about my birth or adoption? Was there a lot of excitement in the family when I was born or adopted? What was I like as a baby?

How do I make you proud of me? What do you wish for my future?

Art and Writing Throughout the Year © 1989

The Family Survey (continued)

Use this page to organize your thoughts.
Once you have completed the page, read
over what you have written. Then use the
information to help you write the rough
draft of Chapter 1.

Chapter title: _____

List four important things you learned about your parents' or
grandparents' childhoods.

1. _____

2. _____

3. _____

4. _____

Describe how your childhood is different from that of your
parents or grandparents.

What other important things did you learn about your
relatives?

Describe what you learned about yourself from talking to your
parents or grandparents.

Art and Writing Throughout the Year © 1989

The Primary Years (CHAPTER 2)

How well do you remember the ages you have already been? Think about the things that you liked when you were younger and how you've changed since then. Use these pages to help you get ideas for Chapter 2.

Chapter title: _____

List three different ages that you remember well. Tell something that you remember about each age.

Age Memory

____ _____

____ _____

____ _____

Have you gone to more than one school? If you have, list the name of each school and the grade you were in when you went there. If you have not, just write the name of your school.

Which teachers do you remember best and why?

Art and Writing Throughout the Year © 1989

The Primary Years (continued)

What were your strongest and weakest subjects in the past two years?

Strongest Subjects Weakest Subjects

_____ _____

_____ _____

_____ _____

_____ _____

List three important things you have learned in school about dealing with other people in your life.

1. _____

2. _____

3. _____

In which grade do you think you changed the most? Explain how and why you changed.

If you could magically go back in time to an earlier grade, what would you do differently?

Read over what you have written. Decide how to organize this information. Write a rough draft of Chapter 2.

A Family Scrapbook (CHAPTER 3)

What is special about your family? Do you have brothers and sisters? Does your family take vacations together? Is the housework in your family shared by all the members?

This chapter should tell readers what your family is like. Use these pages to help you get ideas for Chapter 3.

Chapter title: _____

List the people that live in your house. Tell what relation each one is to you.

Name	Relation
_____	_____
_____	_____
_____	_____
_____	_____

Do you have brothers and/or sisters or are you an only child? Describe the feelings you have about your situation.

Do you have regular chores at your house? If so, what are they?

_____	_____
_____	_____
_____	_____

Art and Writing Throughout the Year © 1989

A Family Scrapbook (continued)

List some of the chores that other members of your family do.

_____ _____

_____ _____

_____ _____

List the reasons why it does or does not make sense to have regular chores in your family.

Does your family go on vacations together? If so, where are some of the places that you have gone?

Has anything special happened to your family while you were on a vacation? If so, list several short words or phrases that describe what happened.

_____ _____

_____ _____

_____ _____

Describe why you like or do not like traveling with your family.

A Family Scrapbook (continued)

What are some of the holidays that your family celebrates?

_____ _____

_____ _____

_____ _____

Pick one holiday with your family. List some words or phrases that describe how your house looks and sounds when your family celebrates that holiday.

_____ _____

_____ _____

_____ _____

Describe how you feel when you are with your family during the holidays.

Does one of your relatives make a special food for one of the holidays? If you can, get the recipe for the food. List the ingredients. Then write the directions for making it. Be sure to tell whose recipe it is.

Read over what you have written. Put away this writing plan. Then write a rough draft of Chapter 3.

Art and Writing Throughout the Year © 1989

Memories of Favorite Things (CHAPTER 4)

How do activities such as playing an instrument, art, writing, dancing, drama, or sports, fit into your life? Has anything special ever happened to you as a result of a hobby? Think about all the things that you've done in the past. Then use these pages to help you get ideas for Chapter 4.

Chapter title: _____

What kinds of hobbies do you have? List the ones that are your favorites.

_____ _____

_____ _____

List several words or short phrases that tell what you like about your hobbies.

_____ _____

_____ _____

_____ _____

Pick one activity that you particularly like. Explain how you feel when you are doing that activity.

Memories of Favorite Things *(continued)*

Have you ever had something special happen to you while you were doing that activity? If so, describe what happened.

Have you ever won an award? If so, what did you win the award for and how did you feel when you won?

Have you ever lost a game that you really wanted to win, or have you ever had someone tell you they did not like your work? If so, describe how you felt when that happened.

Pick one of the activities that you like to do. On a separate piece of paper, write a short poem that describes the activity and explains why you like the activity.

Read over what you have written. Put away your writing plan. Write a rough draft of Chapter 4.

Thoughts About the Future (CHAPTER 5)

Think about what it would be like to be an adult. What would you like to be able to do? What type of life would you like to lead? Use these pages to help you get ideas for Chapter 5.

Chapter title: _____

List some things you would like to be good at.

_____ _____

_____ _____

List some places you would like to live.

_____ _____

_____ _____

List the jobs you would like to do. What do you imagine yourself doing in each job?

Job What I would do

_____ _____

_____ _____

_____ _____

What will life be like for you ten, twenty, thirty, forty and fifty years from now? List some words or short phrases that describe how life will be at each age.

_____ _____ _____

_____ _____ _____

_____ _____ _____

_____ _____ _____

Thoughts About the Future *(continued)*

Describe or sketch pictures of how you
think you will look at each age. These are
just preliminary sketches, so do them
quickly.

Ten years from now	**Twenty years from now**	**Thirty years from now**

Forty years from now	**Fifty years from now**

Look over what you have written and drawn. Then use these
notes to help you draw the pictures and write the captions for
Chapter 5. Draw each final drawing on a separate piece of art
paper. Write your captions on lined paper, revise them, and
cut them out. Glue each caption under its drawing.

Art and Writing Throughout the Year © 1989

Appendix D: Recipes

POSADA TREATS

What You Need

(For 50 children)

- Dried fruits, such as mangoes, papayas, and apricots
 (Ask five children to bring one bag each.)
- Large flour tortillas
 (Ask five children to bring eight tortillas each.)
- Salad oil
 (Ask two children to bring one bottle each.)
- Sugar
 (Ask two children to bring one cup each.)
- Cinnamon
 (Ask two children to bring one container each.)
- Paper napkins
 (Ask two children to bring thirty napkins each.)
- Electric frying pan

Directions

1. Have five children carefully tear the dried fruits into about 60 pieces. (Make sure they wash their hands first!) Arrange the fruit on plates.

2. Heat the oil until it is hot. Then fry the tortillas until they have small bubbles all over the surface. (This should not take more than a minute once the oil is hot.)

3. Have one child pat off excess oil, another child sprinkle the tortillas with sugar, and another sprinkle the tortillas with cinnamon.

4. Ask other children to split the tortillas into four parts once they have cooled slightly. Arrange on platters.

5. Serve the fruit and bunuelos after the posada procession.

EGG FOO YONG

What You Need

(For 8 children)

- 12 eggs
- Fresh ginger
 (a piece the size of
 a thumbnail)
- Two cloves of garlic
- Mung beans
- Three green onions
- Salt or soy sauce
- Electric frying pan
- Large bowl
- Long wooden spoon
- Cutting board
- Paper plates
- Chopsticks

Directions

1. Have three children each break four eggs into the large bowl. Have another child stir the eggs thoroughly.

2. Help two more children peel and dice the ginger and chop the garlic and green onions. Let the children add these to the bowl.

3. Have another child gather two handfuls of mung beans and add them to the bowl.

4. Have another child add salt and stir the ingredients together.

5. Pour the mixture into the heated pan and let each "cook" take turns stirring.

6. Once the eggs are cooked, serve on paper plates. Let the children eat with chopsticks.

Appendix E: Suggested Readings for Art and Writing

For Young Writers and Their Teachers:

Strunk, William and E. B. White. *The Elements of Style*. 3rd ed. New York: Macmillan, 1978.

Every teacher needs to have this book on his or her shelf. With it, I keep one of many copies of E. B. White's *Charlotte's Web*. Through *Charlotte's Web,* children come to know the author. If properly encouraged, they will be unafraid to seek answers about punctuation or usage in *The Elements of Style.* The rules in the final chapter, "An Approach to Style," can be typed up for children and taught in discreet units. Do read from both books when teaching writing—the children will learn more from these than from any exercise book.

Parnow, Elaine, ed. *The Quotable Woman.* 2 vols. New York: Pinnacle Books, 1980.

This paperback collection of quotable quotes from inspiring women is a terrific classroom reference tool. Only .5% of Barlett's entries and 1% of *The Oxford Book of Quotations* entries are from women. *This* book should encourage your female students to write!

Macrocrie, Ken. *20 Teachers.* New York: Oxford University Press, 1984.

Macrocrie is an English professor on staff at the Bread Loaf School of English in Middlebury, Vermont. This is not a book on writing (though he has written several on the subject). It is simply the most inspiring book written on the subject of teaching that I have read in a decade. That is why I include it here.

Calkins, Lucy McCormick. *The Art of Teaching Writing*. Portsmouth, New Hampshire: Heinemann Educational Books, 1986.

The Art of Teaching Writing is an inspirational text. Lucy Calkins, a student of Donald Graves, writes from the heart about children and about teaching. I filled up countless pages taking notes as I read her book the first time. It is a practical guide but also a philosophical treatise. I am a better writing teacher for having read her book.

Atwell, Nancie. *In the Middle.* Upper Montclair, New Jersey: Boynton/Cook, 1987.

Atwell's book seems to be aimed at junior high school teachers. Teacher of writers of K-6 classrooms: *Do not be misled by this title!* Atwell's organizational methods are applicable to all writing classrooms. Every writing workshop and conference I've attended this year has been filled with enthusiasts of Atwell's work, with reason!

Caplan, Rebekah and Catharine Keech. *Showing Writing.* Berkeley: Bay Area Writing Project, 1980.

Elementary school students can easily learn the difference between showing and telling in writing. Caplan stresses the importance of being specific. She provides teachers and children with linguistic tools. *How* do you provide a student with specific ways to improve her writing dramatically? Read Caplan's book(s)!

Tiedt, Iris and Lisa Johnson. *Catching the Writing Express.* Belmont, CA: David S. Lake Publishers, 1987

Tiedt, Iris and Mary Young Williams. *Enjoying the Written Word.* Belmont, CA: David S. Lake Publishers, 1987

Tiedt, Iris and Nora Ho. *Learning to Use Written Language.* Belmont, CA: David S. Lake Publishers, 1987

These three books came out of the South Bay Writing Project and they reflect the kind of creative work elementary teachers can do with young writers.

Journals Worth Reading:

The Writing Teacher (Ed. Lori Mammen), P.O. Box 791437, San Antonio, Texas. 78279-1437

Language Arts (National Council of Teachers of English), 1111 Kenyon Road, Urbana, Illinois.

The National Writing Project Quarterly, For sponsors of the National Writing Project. If interested, send $25.00 to The Bay Area Writing Project, School of Education, University of California, Berkeley, California 94720

For Teachers Who Write Themselves:

Zinsser, William. *On Writing Well.* New York: Harper and Row, 1985.

Read *On Writing Well* and enjoy. It's both amusing and engrossing. Zinsser's book is filled with examples of writing that works and writing that doesn't work. His commentary on both is instructive.

For Young Artists and Their Teachers:

In addition to the standard art resource books, you should keep a good supply of art masterpiece reproductions and coloring books on hand. Several good sources are included in the following list.

Silberstein-Storfer, Muriel and Mablen Jones. *Doing Art Together.* New York: Simon & Schuster, 1983.

This book was written for parents of children of all ages. It is an art book, not a craft book. The authors attempt to teach both techniques and a bit of art history to parents and children. If you have never taken an art history class before, this is a fine place to start.

Martin, Mary. *Masterpieces: A Coloring Book.* Philadelphia: Running Press, 1981.

Coloring books have come back into vogue in recent years, and the best of the genre are quite worthwhile. *Masterpieces* includes some of the best known and best loved works of the Impressionists. You might introduce the children to Vincent Van Gogh by playing the song "Vincent," having the children color in one of his masterpieces, and then reading to them from one of the biographies about Van Gogh.

Art and Man Magazine. Lyndhurst, NJ: Scholastic Inc. (To order, write P.O. Box 644, Lyndhurst, NJ 07071)

I've included the address of this publication because I recommend it so highly. Each year, Scholastic publishes six different issues, and the September issue is available

to teachers for preview without charge. Although the intended market for the magazine is junior high, I have used it in the intermediate grades successfully. Each issue includes full color reproductions of art masterpieces, life stories of particular artists, a biographical sketch of a young artist, and an art lesson. If your classroom chooses to subscribe to this magazine, save the back issues for future students to use as reference.

Both authors welcome comments or suggestions about *Art and Writing Throughout the Year*. Contact us well in advance of conference dates if you are interested in scheduling an *Art and Writing* workshop.

Merrill Watrous
2545 Birch Lane
Eugene
Oregon 97403

Irisa Tekerian
850 30th Avenue
San Francisco
California 94121

Art and writing workshops for faculties or larger groups can be scheduled. Both lecture-demonstration or make-and-take workshop formats are offered. Please write well in advance of the date you wish us to speak so that we can all plan effectively. Include several possible dates in your letter, especially if you are not in the San Francisco Bay Area. Please include a daytime and evening phone number.